BASEBALL
IN
HOT SPRINGS

BASEBALL
IN
HOT SPRINGS

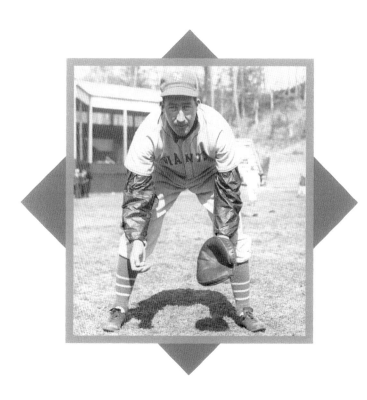

Mark Blaeuer

ARCADIA
PUBLISHING

Copyright © 2016 by Mark Blaeuer
ISBN 978-1-4671-1505-6

Published by Arcadia Publishing
Charleston, South Carolina

Printed in the United States of America

Library of Congress Control Number: 2015943733

For all general information, please contact Arcadia Publishing:
Telephone 843-853-2070
Fax 843-853-0044
E-mail sales@arcadiapublishing.com
For customer service and orders:
Toll-Free 1-888-313-2665

Visit us on the Internet at www.arcadiapublishing.com

For the baseball players, historians, and fans of Hot Springs.

CONTENTS

ACKNOWLEDGMENTS

I want to thank my wife, Sharon Shugart, who allowed me to monopolize our computer. I have learned a great deal from my Hot Springs, Arkansas, Historic Baseball Trail colleagues: Mike Dugan (who, with Susan Dugan, reviewed the manuscript), Don Duren, Bill Jenkinson, and Tim Reid. Without Steve Arrison, chief executive officer of Visit Hot Springs, there would be no Baseball Trail. In addition, he referred me to Arcadia Publishing. The Garland County Historical Society (Liz Robbins, executive director) generously supported my efforts in numerous ways; Mike Blythe and Clyde Covington took a field trip with me one day to nail down where the George Barr Umpire School photographs had been snapped. Orval Allbritton, Gail Ashbrook, and Donnavae Hughes were always helpful. I am indebted to those who aided me in obtaining images and identifying players therein; along with those already enumerated, these include Gary Ashwill (Agate Type), Dr. Raymond Doswell (vice president of Curatorial Services, Negro Leagues Baseball Museum), Peter Gorton (The Donaldson Network), Caleb Hardwick, McKinzie Lambert, R.J. Lesch, W.L. Pate Jr. (president, Babe Didrikson Zaharias Foundation), Greg Patterson, and Chris Siriano (director, House of David Museum). Others who graciously provided images were Tom Blake at the Boston Public Library, Jeff Bridgers at the Library of Congress, Tom Hill with the National Park Service in Hot Springs, John Horne and Pat Kelly at the National Baseball Hall of Fame, as well as private collectors Jeff Carpenter, Pete Costanzo, and M. Beau Durbin. Thanks to Larry Foley (chair, Walter J. Lemke Department of Journalism, University of Arkansas) and to Tim Nutt (head, Special Collections, University of Arkansas Libraries) for the rare Hot Springs Arlingtons photograph. Numerous librarians around the country opened their archives or diligently responded to my queries. Thanks to Ray Sinibaldi for clarification and encouragement about copyright issues. I certainly need to thank Jesse Darland, Maggie Bullwinkel, Jim Kempert, and others at Arcadia for their patience and commitment to this project. Despite such copious help from all quarters, imperfections may remain, and those faults are of course mine alone. Finally, I extend heartfelt apologies to anyone whose name and assistance I may have inadvertently omitted.

INTRODUCTION

While nobody knows when the first baseball game occurred in Hot Springs, Arkansas, a huge part of the story began in 1886, when the Chicago White Stockings (later known as the Cubs) of A.G. Spalding and Cap Anson arrived for spring training. They exercised, they bathed in hot spring water (a process considered medicinal and regulated by the federal government), and they played the national sport. They returned several times, and other major-league clubs followed: the Pittsburgh Pirates, Cleveland Spiders, Buffalo Bisons, Cincinnati Reds, St. Louis Perfectos (just before their name was changed to the Cardinals), Boston Red Sox, Detroit Tigers, New York Highlanders (later called the Yankees), Brooklyn Dodgers, St. Louis Browns, Philadelphia Phillies, and New York Giants. The Pirates and Red Sox especially loved the facilities and environment here, returning to Hot Springs quite often.

Minor-league clubs got in on the fun, too. The Denver Grizzlies, Milwaukee Brewers, St. Paul Apostles, Minneapolis Millers, Akron Buckeyes, Indianapolis Indians, and Baltimore Orioles trained here. Other minor-league teams played exhibition games in Hot Springs.

Among various Negro League teams conducting spring training in the great resort town were the Kansas City Monarchs, Homestead Grays, Pittsburgh Crawfords, Baltimore Elites, Memphis Red Sox, New York Black Yankees, Houston Eagles, New Orleans Eagles, and Detroit Stars. Barnstorming tours brought numerous other African American clubs here, such as the Chicago American Giants, Birmingham Black Barons, Indianapolis Clowns, Cleveland Buckeyes, and New York Cubans.

Another club honed its players into shape at Hot Springs—a bearded outfit from Benton Harbor, Michigan, known far and wide as the House of David. Sometimes, ballplayers unable to catch on with more orthodox professional teams would sign a contract to tour with the Davids, who were true attractions in their own right.

Hundreds of individual major and minor leaguers, as well as players from the Negro Leagues, traveled here at their own expense, to get into condition for their teams' formal spring-training camps elsewhere. Some clubs officially sent smaller contingents—graying veterans with creaky knees and sore shoulders, pitchers and catchers (the "heavers and receivers"), or the "fat men" who needed to boil a few pounds off their girth. They took courses of baths, hiked the mountain trails, and spent lots of time playing golf.

Hot Springs could even boast of its own teams. The most familiar to residents was undoubtedly the Hot Springs Bathers of the Cotton States League, but a full roster of local squads would also include the Hot Springs Vaporites, Vapor City Tigers, and many others.

Where, specifically, did all this baseball take place? The earliest known ball field in Hot Springs, used beginning in 1886 and into the 1890s, was located near Ouachita Street, in the vicinity of where the Garland County Courthouse stands today. This is where the White Stockings played. Whittington Park was constructed in 1894, just northwest of where Whittington Avenue meets Woodfin Street. Also called Ban Johnson Field and McKee Field, it offered a grandstand, bleachers (concrete remnants of which remain on the hillside), and a quirky configuration that evolved over time. It lasted into the 1940s. Majestic Park, the former site of an 1890s horseracing

track, was developed in 1909. Located where the Boys & Girls Club of Hot Springs is today, it was later rearranged and divided into fields, including Dean and Jaycee, where the sound of bat meeting ball still rings out. Fogel Field, also known as Fordyce Field and Older Field, was built in 1912. It survives as a vacant "field of dreams" greenspace behind the Arkansas Alligator Farm & Petting Zoo. Now gone, Highland Park was located on Grove Street. It was used by local African American teams in the 1920s and 1930s. Sam Guinn Stadium, constructed in 1935 on Crescent Street, was the new athletic field for the African American high school in Hot Springs (Langston). The Baltimore Elites trained there in 1944. Greater St. Paul Baptist Church stands on this spot today.

By the 1930s, another late-winter/early-spring phenomenon arose. Youngsters who wanted to soak up the game's basics and finer points from real major leaguers could attend institutes of diamond learning. Ray Doan's All-Star Baseball School, which operated in Hot Springs from 1933 to 1938, featured instructors like Rogers Hornsby, Grover Cleveland Alexander, George Sisler, Dizzy and Daffy Dean, Burleigh Grimes, Tris Speaker, and Cy Young. The peach-fuzzed aspirants tendered their tuition, many expecting to emulate the "professors," but just a handful made it to the Big Show. Hundreds of the teens and 20-somethings, however, did get placed with talent-hungry minor-league clubs, who sent scouts to the school's practice games. After Doan took his business elsewhere in 1939, Hornsby filled the vacuum with his Baseball College. This enterprise lasted, off and on, through 1956. A third such school in Hot Springs taught student umpires, and dozens of these novice adjudicators found employment in organized ball at lower levels (two made it to the majors). An arbiter from the National League, George Barr, ran this school in the Spa City between 1935 and 1940 prior to moving his academy to Florida.

Eventually, major- and minor-league baseball magnates abandoned Hot Springs. Early spring weather was, by and large, fair in Arkansas—but more fickle than in Florida and Arizona. Rain, cold, and even snow occasionally spoiled practice sessions in March, and owners ultimately decided not to let their players enjoy a mere Vapor Valley vacation when the elements refused to cooperate. A different kind of adverse element was the presence of nightclubs, casino gambling, and underworld figures. Such concerns would have been especially important after the Black Sox scandal. High-quality practice facilities beckoned from sunnier states, too, and did not need to be shared with so many other clubs. The increasing number of teams concentrated for spring training in Florida, and then Arizona, enabled sizable Grapefruit and Cactus Leagues to organize: potential opponents were easier to reach, and this could actually involve "home" and "away" games. The major-league exodus from Hot Springs was obvious by the 1920s and nearly complete by 1940. Several Negro League clubs and a few individual players kept coming, mostly for the baths, into the 1950s. The Hot Springs Bathers minor-league team called it quits after 1955. Baseball continued locally with high school and American Legion ball, but only recently has the more glamorous history been revived with the publication of books like *Boiling Out at the Springs* by Don Duren. In 2012, the Hot Springs, Arkansas, Historic Baseball Trail was dedicated. A number of plaques around town allow fans to relive the Golden Age of Hot Springs hardball from the comfort of their cars. A website on Arkansas baseball history, a large portion of which is dedicated to Hot Springs, can now be consulted. A Hot Springs baseball museum has begun to interpret the story as well. It is hoped that this book, with its vintage photographs, will function as a paper-and-ink time machine to carry readers back to those days.

AT THE BALLPARKS

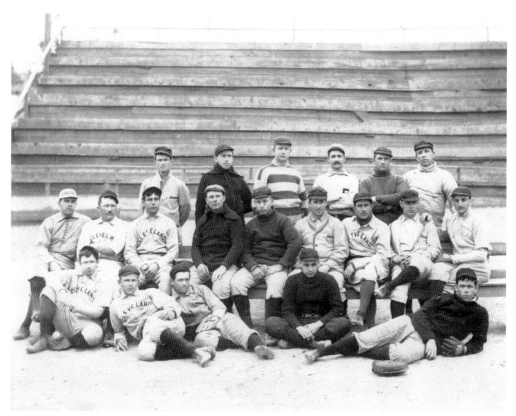

The National League's Cleveland Spiders trained at Whittington Park in April 1899. Shown here are, from left to right, (first row) Jack Powell, Lou Criger, Jim Paschal, Herman Long (Boston Beaneaters), and Frank Bates; (second row) Jake Stenzel, Ed McKean, Ossee Schreckengost, Jack O'Connor, Patsy Tebeau, Cupid Childs, Zeke Wilson, Harry Blake, and Bobby Wallace; (third row) Sport McAllister, Emmet Hedrick, Cy Young, George Bristow, Jesse Burkett, and Chief Zimmer. Many of these players would soon be transferred to the St. Louis Perfectos due to a change in team ownership. (Courtesy of the National Baseball Hall of Fame.)

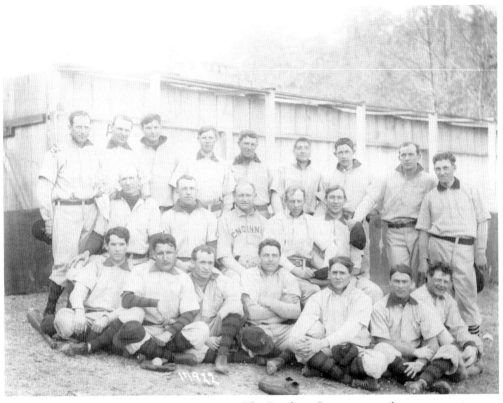

The Pittsburg Pirates pause during a practice at Whittington Park in March 1905. Player-manager Fred Clarke (third row, far left) guided the Corsairs to an excellent record of 96-57, but that was only good enough for second in the National League race, behind the New York Giants. Note the player wearing a Cincinnati jersey; this is Henry "Heinie" Peitz, traded by the Reds to Pittsburg the previous month. He evidently had not yet received his Pirates uniform. The Steel City's name was spelled without the "h" between 1890 and 1911. (Courtesy of Caleb Hardwick.)

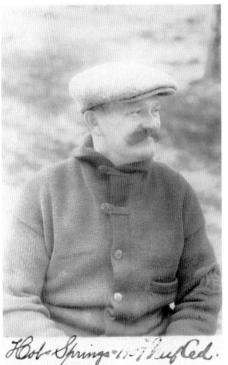

Boston business owner Michael T. McGreevey led a raucous group of Red Sox fans known as the Royal Rooters. In 1907, as in other years, he traveled to spring training with the team. His "Nuf Ced" nickname derived from a habit of ending arguments at his Third Base Saloon by slamming a fist on the bar and shouting "Enough said!" (Courtesy of the McGreevey Collection, Boston Public Library.)

AT THE BALLPARKS

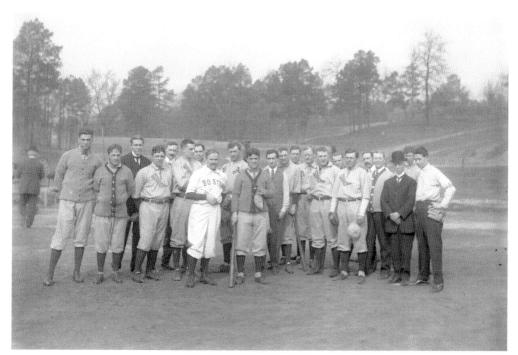

McGreevey promised a diamond ring to the Boston player—of the Red Sox or Beaneaters—who stole the most bases during the 1908 season. Red Sox second baseman Amby McConnell, who pilfered 31 bags, received his award at Hot Springs on March 1, 1909. McGreevey quipped, "I had a speech prepared for this occasion, Amby, but someone stole it." (Courtesy of the McGreevey Collection, Boston Public Library.)

Here, 10 members of the Pittsburg club sit for a partial team portrait at Whittington Park around March 1909. Tommy Leach (second row, center) brought an advance squad of mostly pitchers and catchers on March 13, and Fred Clarke arrived with more players a short time later. (Courtesy of Caleb Hardwick.)

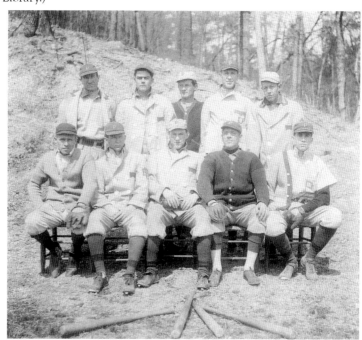

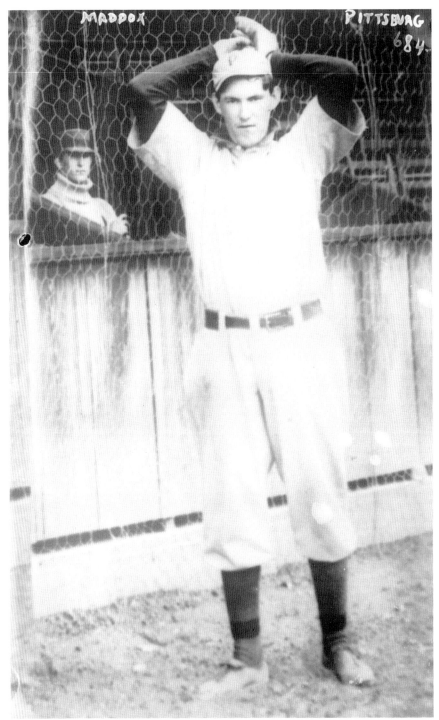

Nick Maddox of the Pirates shows off his windup at Whittington Park around 1909. Maddox racked up a win-loss total of 43-20 in four major-league seasons, all with the Buccos. (Courtesy of the George Grantham Bain Collection, Library of Congress.)

AT THE BALLPARKS

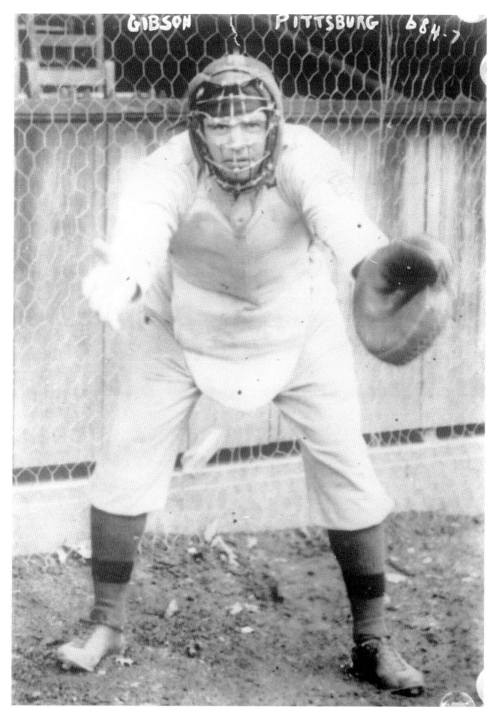

Pittsburg's George "Moon" Gibson is ready for action at Whittington Park around 1909. The Ontario-born catcher played 14 major-league seasons, then managed another seven years in the bigs. The sleeve logo "PBC" stands for Pittsburg Baseball Club. (Courtesy of the George Grantham Bain Collection, Library of Congress.)

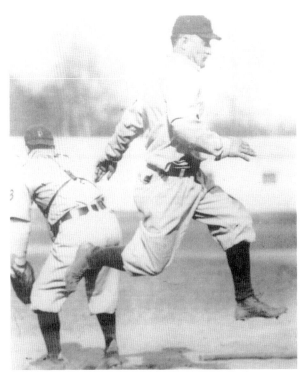

Honus Wagner, legendary Pirates shortstop, shows why he was called "the Flying Dutchman." Photographer Frank Bringaman froze this moment around 1910 at Whittington Park. Wagner is wearing the previous year's uniform. (Courtesy of the Carnegie Museum of Art, Pittsburgh.)

From left to right, the Pirates' Honus Wagner, Tommy Leach, and Fred Clarke take a breather at Whittington Park around 1911. All three broke into the majors with the Louisville Colonels and continued as teammates when the Louisville franchise moved to the Steel City in 1900. (Courtesy of Pete Costanzo.)

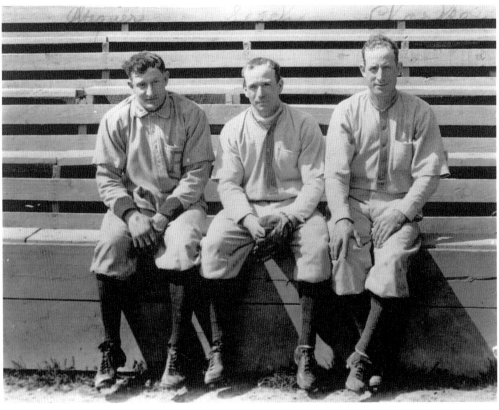

AT THE BALLPARKS

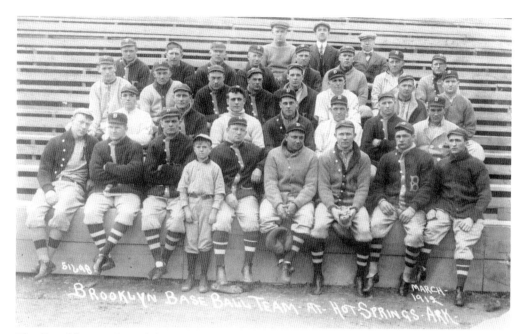

The Brooklyn Dodgers (also known as the Superbas) conducted spring training in 1912 at Whittington Park. Shown here are two hall of famers: Zack Wheat (first row, second from right) and Wee Willie Keeler (fourth row, fourth from left), who was now a coach. (Courtesy of the George Grantham Bain Collection, Library of Congress.)

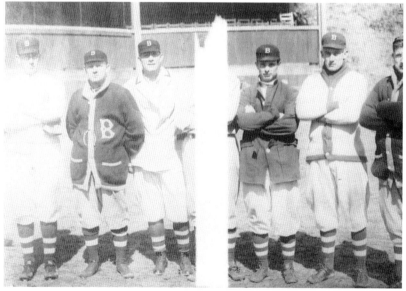

Several Dodgers stand in front of the Whittington Park grandstand in 1912. Manager Bill Dahlen wears a horseshoe, perhaps for good luck—but the talisman failed to help. His charges would finish the upcoming campaign with a record of 58-95. Cy Seymour (third from left) was a pitcher turned hitter and past his prime. He was trying to catch on with Brooklyn, but he ended up with Newark that year. (Courtesy of the George Grantham Bain Collection, Library of Congress.)

Frank Allen of the Dodgers trains at Whittington Park in 1912. The February 17, 1913, *Brooklyn Daily Eagle* said that after the wild southpaw "reported at Hot Springs, Ark., last February . . . he was long and earnestly coached in the useful knack of getting the ball into the same county with the batter and was improving at a gratifying rate, when he was stricken with the ague and fever." He went 3-9 in 1912. (Courtesy of the George Grantham Bain Collection, Library of Congress.)

The Philadelphia Phillies ride the bleachers at brand-new Fogel Field, named for their team owner/president Horace Fogel. Behind them is the "Leap-the-Dips" roller coaster, constructed around 1910. (Courtesy of the George Grantham Bain Collection, Library of Congress.)

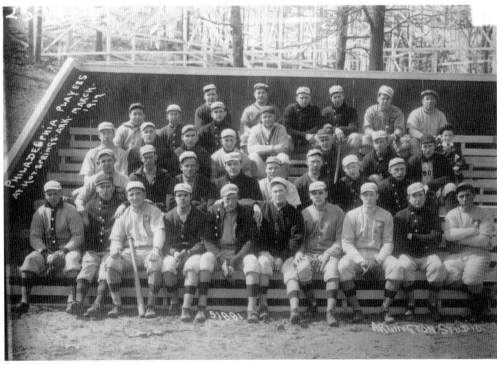

AT THE BALLPARKS

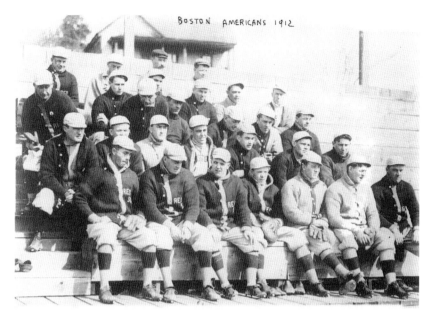

Above, the Boston Red Sox wear gloves and cleats on an apparently chilly day at Majestic Park. Two players, including Jake Stahl, are leaning forward as if just sitting down or standing up. Boston would go on to win the 1912 World Series under Stahl, who doubled as manager for the Carmine Hose. Below in 1912, four players—one an ex-member, and one a once-and-future member of the Red Sox—get together at Whittington Park. Bill Carrigan (far left) and Jake Stahl (second from left) both would play with the Boston Americans in 1912. Cy Young (second from right) was working out amid rumors that he would perform in the majors again (it did not materialize). Fred Anderson (far right) sipped a proverbial cup of coffee with Boston in 1909 and would pitch for the team again in 1913. In 1912, Anderson wound up toiling for the New England League's Brockton Shoemakers. (Both, courtesy of the George Grantham Bain Collection, Library of Congress.)

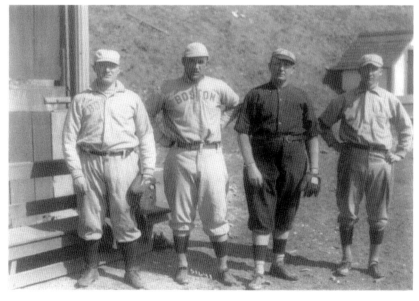

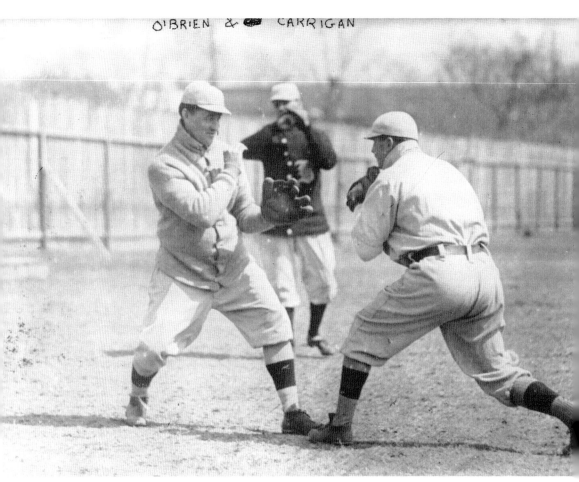

Buck O'Brien and battery-mate Bill Carrigan of the Red Sox "spar" at Majestic Park in March 1912. The Cleveland *Plain Dealer* reported that a real boxer from Boston, Jack O'Keefe, "died in a rooming house" on March 27 in Hot Springs, and the team raised money to give him "a proper funeral." (Courtesy of the George Grantham Bain Collection, Library of Congress.)

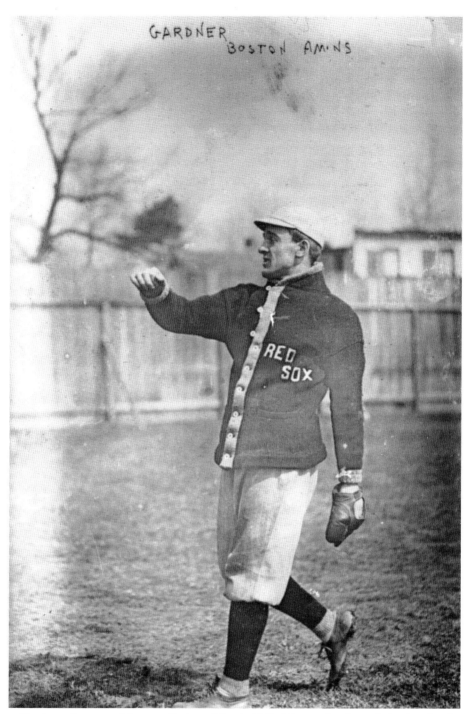

Larry Gardner throws at Majestic Park in March 1912. The multitalented third-sacker batted lefty, sang baritone in the Red Sox barbershop quartet, coached university baseball for decades, and was perhaps the finest player ever to hail from Vermont. (Courtesy of the George Grantham Bain Collection, Library of Congress.)

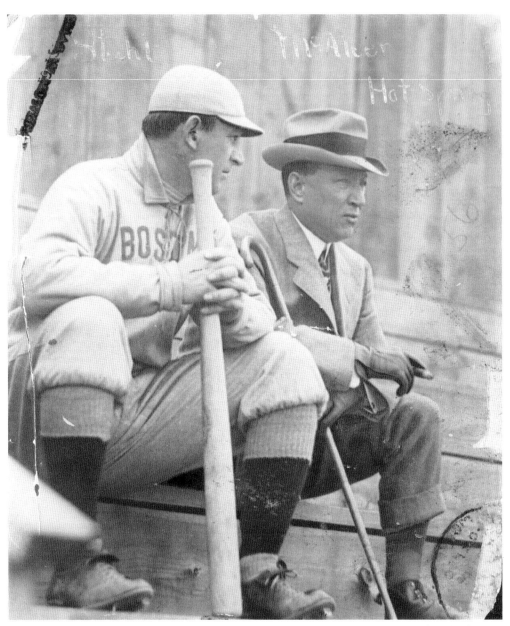

In March 1912, player/manager Jake Stahl and the team's part-owner Jimmy McAleer (with cane and cigar) discuss Red Sox matters at Majestic Park. "Loafer" McAleer had been a player and manager, too, but eventually had a falling out with Stahl, which resulted in a lifelong rift between McAleer and American League president Ban Johnson. (Courtesy of the McGreevey Collection, Boston Public Library.)

AT THE BALLPARKS

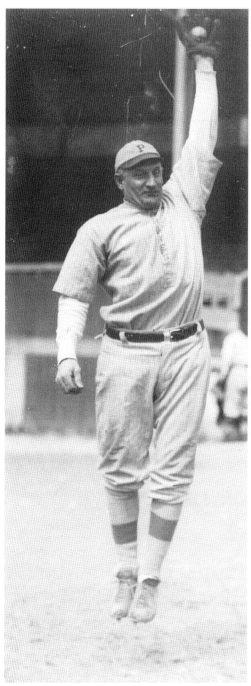

Honus Wagner leaps at Whittington Park around March 1912. Manager Fred Clarke announced on March 16, in Hot Springs, that "Hans" would be field captain that year. The *Pittsburgh Gazette Times* observed, "The appointment to the captaincy seems to have given [Wagner] additional pepper. He has the chattering habit. His deep-chested tones are heard all over the lot." (Courtesy of Caleb Hardwick.)

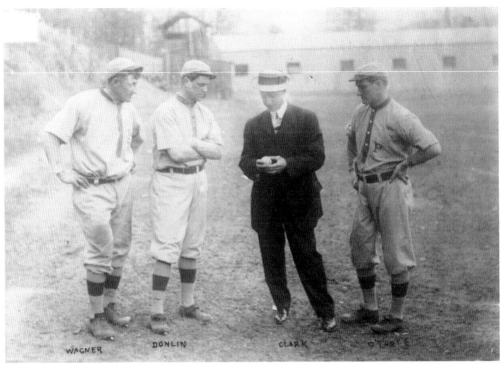

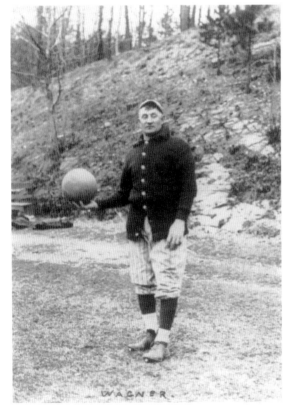

Shown here are, from left to right, Honus Wagner, Mike Donlin, Fred Clarke, and Marty O'Toole. They examine a baseball at Whittington Park around 1912. Clarke was still the Pittsburgh manager, but he had retired as a player. The carbarn for Hot Springs trolleys occupies the background. (Courtesy of the George Grantham Bain Collection, Library of Congress.)

Honus Wagner holds a medicine ball at Whittington Park in 1914. Numerous clubs used these balls, which came in various sizes and weights. One evening that March in the Eastman Hotel lobby, Wagner, 40, shared a fitness secret with the Pirates rookies: hunting, walking, and basketball all winter long. "I never get sore from training. That is because I am always in condition." (Courtesy of the George Grantham Bain Collection, Library of Congress.)

AT THE BALLPARKS

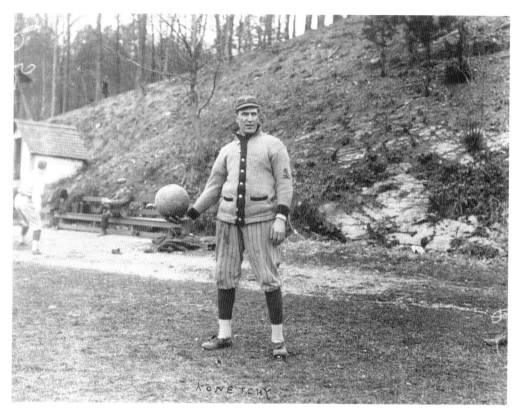

Ed Konetchy holds what is probably the same medicine ball Wagner held for the photographer, a few minutes earlier or later at Whittington Park in 1914. Note his mismatched clothing: the Cardinals had traded the first baseman to Pittsburgh on December 12, 1913, and the Pirates may not have issued him a sweater as of this photograph. The structure at left is a springhouse for cold water. (Courtesy of the George Grantham Bain Collection, Library of Congress.)

George Herman Ruth Jr. pitches at Majestic Park in 1915 during his first major-league spring training. The lean portside hurler would notch 18 victories for the Red Sox that championship season. In a hint of what was to come, he would hit .315, with four home runs. Another George, G.T. Murray of the *Boston Journal*, took the photograph. (Courtesy of Caleb Hardwick.)

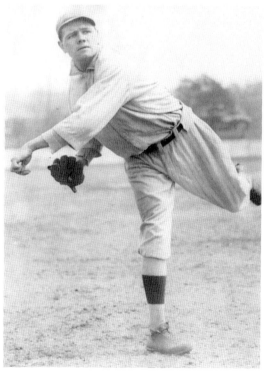

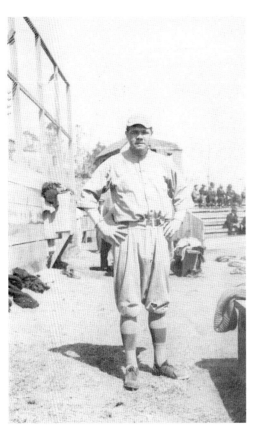

The future Sultan of Swat gazes into posterity at Majestic Park around 1915. Ruth was one of several pitchers vying for a slot in the Boston rotation. He had gone 2-1 with a 3.91 earned run average in 1914, after being purchased from Baltimore in July. (Courtesy of Pete Costanzo.)

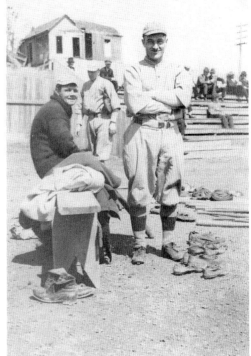

Larry Gardner stands amid hardball equipment at Majestic Park in this c. 1915 photograph. A young Babe Ruth (left), also in good humor, is not yet the center of attention. (Courtesy of Pete Costanzo.)

AT THE BALLPARKS

Forrest "Hick" Cady stares menacingly in a photographic study at Majestic Park around 1915. Cady, an able defensive backstop for the Red Sox, was a favorite of pitcher Smoky Joe Wood. In a rare accomplishment, he once pinch-hit for Babe Ruth. (Courtesy of Pete Costanzo.)

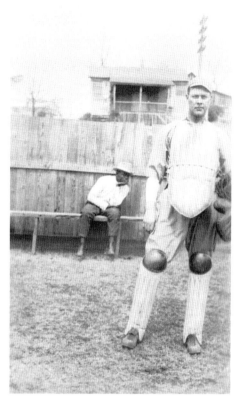

The Pittsburgh Pirates and Boston Red Sox assemble at Whittington Park, probably on March 26, 1916, in pregame hoopla to celebrate the resumption of Sunday baseball at Hot Springs (blue laws had been strict). The De Soto Spring Co. provided cool refreshment: "gaily decorated rack[s] of bottles of this water [were] wheeled to the home plate," beribboned in team colors, according to the *Tulsa World*. "A bevy of pretty local society girls" was present to hand each player an appropriately labeled bottle. The *Pittsburgh Gazette Times* later reported that the game was canceled for meteorological reasons: "The air was damp and cold and at noon light drizzles began to descend." (Courtesy of Don Duren and Leon Dodd.)

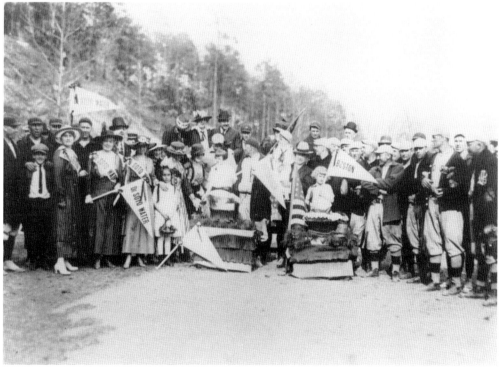

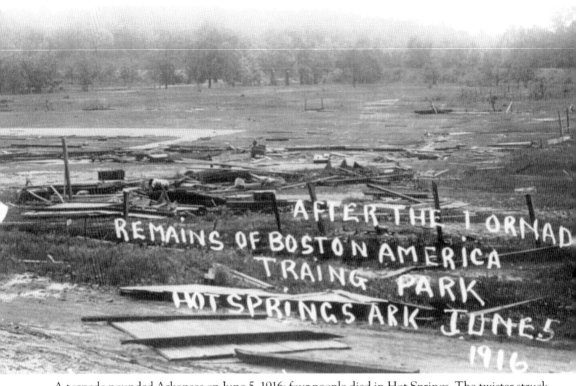

A tornado pounded Arkansas on June 5, 1916; four people died in Hot Springs. The twister struck Oaklawn first, destroyed a Methodist church and several homes, and damaged the city power plant. Majestic Park was "swept clean," according to news reports. (Courtesy of the Garland County Historical Society.)

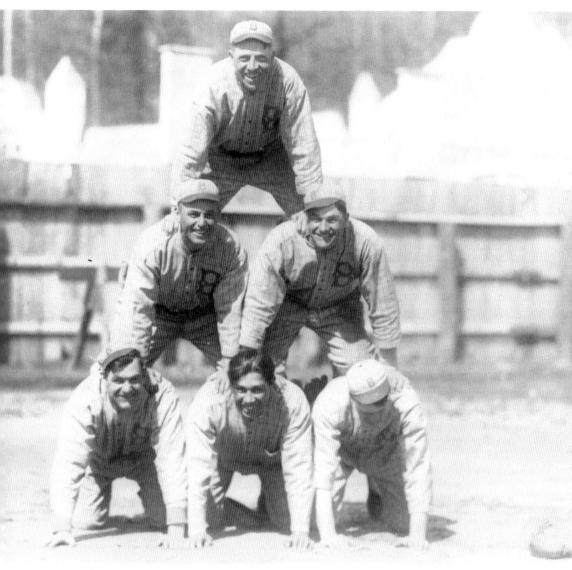

Several members of the Brooklyn Dodgers form a human pyramid at Whittington Park in March 1917. From left to right are (bottom row) Henry "Hi" Myers, John "Chief" Meyers, and Ivan "Ivy" Olson; (middle row) Jim Hickman and Zack Wheat; (top) Jimmy Johnston. The team was also called the Robins in this period, after their manager, Wilbert Robinson. (Courtesy of the National Baseball Hall of Fame.)

BOSTON RED SOX *(World Champions, 1916)*
BROOKLYN NATIONALS *(National League Champions, 1916)*

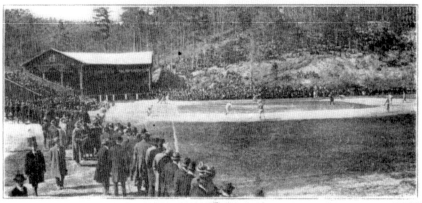

TWO BEST WORLD'S CLUBS AT PLAY, SPRING OF 1917, WHITTINGTON PARK

HOT SPRINGS STREET RAILWAY COMPANY

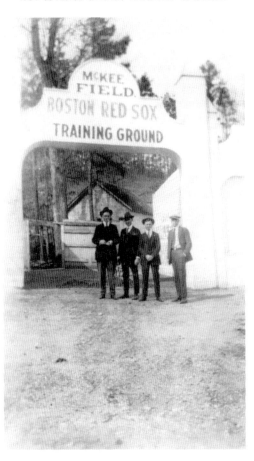

The 1916 World Series foes, Boston and Brooklyn, square off again in March 1917, both teams in the Spa City for spring training. Note the overflow of spectators at Whittington Park. The teams played on two consecutive Sundays, and the Dodgers won both games. The two umpires were major-league arbiters Hank O'Day and Francis "Silk" O'Loughlin. (Courtesy of the Garland County Historical Society.)

Shown here are, from left to right, Hal Brown, Doc Yack, Coo Coo Cochran, and Goof Duke. The local musicians pause at the entrance to McKee Field around 1921. Yack's name may have been inspired by Sid Smith's *Old Doc Yak* comic strip, which ran in the *Chicago Tribune* between 1911 and 1917. The Red Sox abandoned Majestic Park for McKee in 1921. (Courtesy of the Garland County Historical Society.)

AT THE BALLPARKS

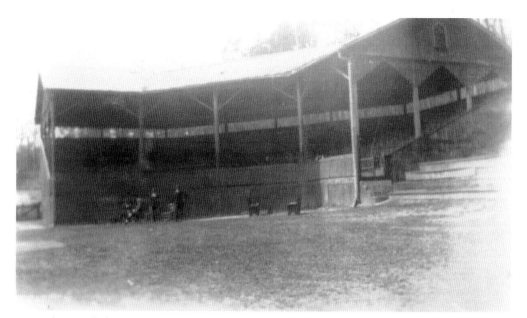

Here, four well-dressed men, perhaps the musicians with the funny names in the previous photograph, linger next to the grandstand at a mostly empty McKee Field around 1921. This was the ball yard formerly known as Whittington; its name was changed around 1920. (Courtesy of the Garland County Historical Society.)

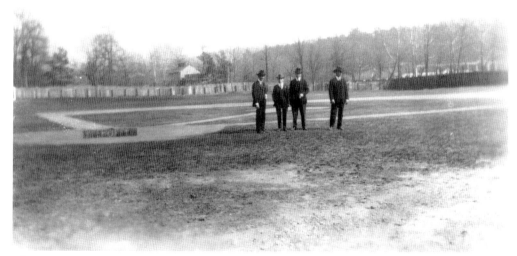

The musicians stand outside the first-base line at McKee Field around 1921. Note the "KEEP OFF" sign at home plate, perhaps left by the groundskeeper. (Courtesy of the Garland County Historical Society.)

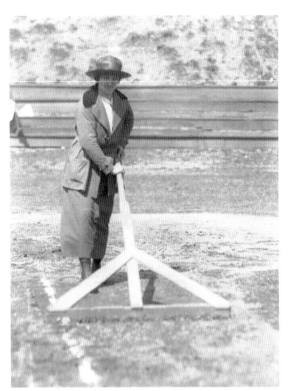

Mamie Wilhelmi became the groundskeeper at McKee Field and Fordyce Field (formerly called Fogel Field) in 1920 when her husband, Otto, left the position to become superintendent of links at the Hot Springs Golf and Country Club. Here, she pushes a squeegee near home plate at McKee. *Muskegon Chronicle* photographer Bob Dorman took the picture, used in a March 31, 1921, article. (Courtesy of the McKinzie Lambert Collection, Garland County Historical Society.)

Mamie Wilhelmi, groundskeeper for the Boston Red Sox and Pittsburgh Pirates when they trained at Hot Springs in the early 1920s, told a *Muskegon Chronicle* reporter in March 1921, "Keeping a ball park in shape for big leaguers is just as important as washing dishes and sweeping the floors." This close-up photograph was taken at McKee Field. (Courtesy of the McKinzie Lambert Collection, Garland County Historical Society.)

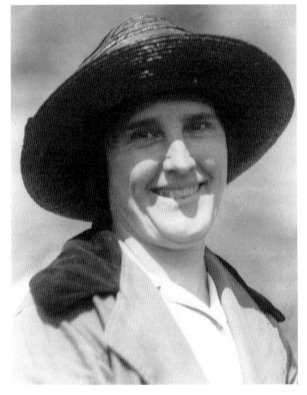

AT THE BALLPARKS

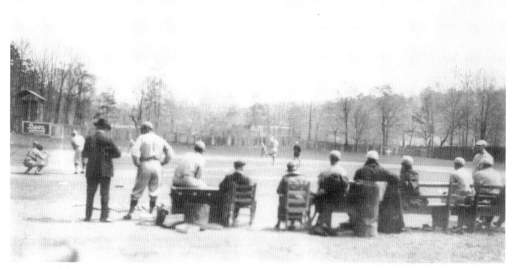

A game, likely of the Red Sox intrasquad variety, takes place at McKee Field around March 1921. Note the bats arranged on the ground near home plate, and what may be a coach serving as umpire behind the pitcher's mound. The all-white caps are leftovers from the 1920 Boston uniform. (Courtesy of the Garland County Historical Society.)

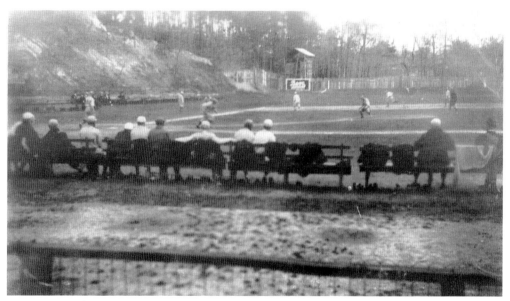

A sparse crowd witnesses an intrasquad Boston Red Sox game at McKee Field. The sign on the wooden fence, near the left field foul line, advertises Bevo. Anheuser-Busch brewed this cereal beverage (nonalcoholic beer) between 1916 and 1929. It reached the height of its popularity in the first years of Prohibition, prior to the widespread availability of bootleg liquor. The structure behind the Bevo sign was part of a rock-crushing business. This photograph was taken around March 1921. (Courtesy of the Garland County Historical Society.)

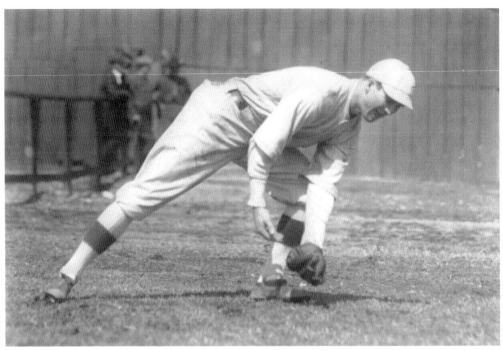

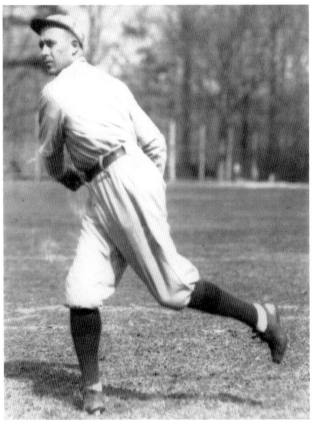

Boston Red Sox infielder Clarke "Pinky" Pittenger, shown here at McKee Field in March 1921, impressed manager Hugh Duffy as a rising star. That spring, however, the rookie performed erratically. He went on to play seven years with the Sox, Cubs, and Reds as a utility man. (Courtesy of the McKinzie Lambert Collection, Garland County Historical Society.)

In March 1921, veteran lefthander Earl Hamilton fires the ball at Fordyce Field. He would go 13-15 that season. Unspectacular but steady, Hamilton once threw a no-hitter for the St. Louis Browns without getting a single strikeout. (Courtesy of the McKinzie Lambert Collection, Garland County Historical Society.)

AT THE BALLPARKS

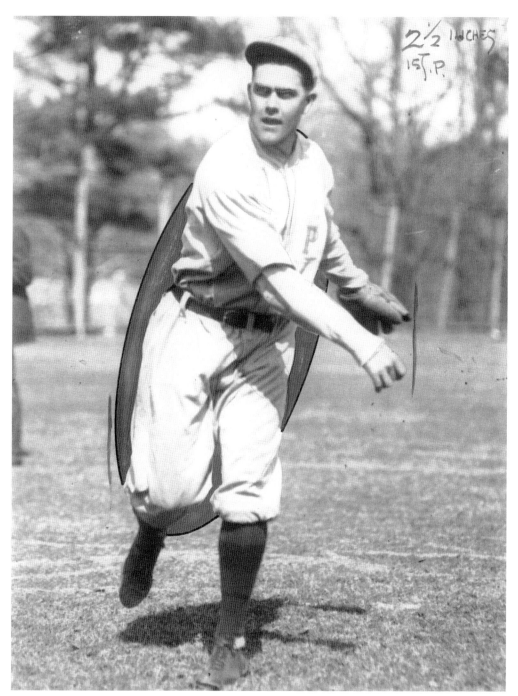

Pittsburgh's Charles "Babe" Adams throws at Fordyce Field in March 1921. "After a hard winter of wood-chopping on his Missouri farm, Babe appears in the best form of his long and remarkable career," wrote Edward Balinger for the March 15 *Pittsburgh Post*. Over 19 seasons, all but one with the Pirates, Adams won 194 games on his pinpoint control. (Courtesy of the McKinzie Lambert Collection, Garland County Historical Society.)

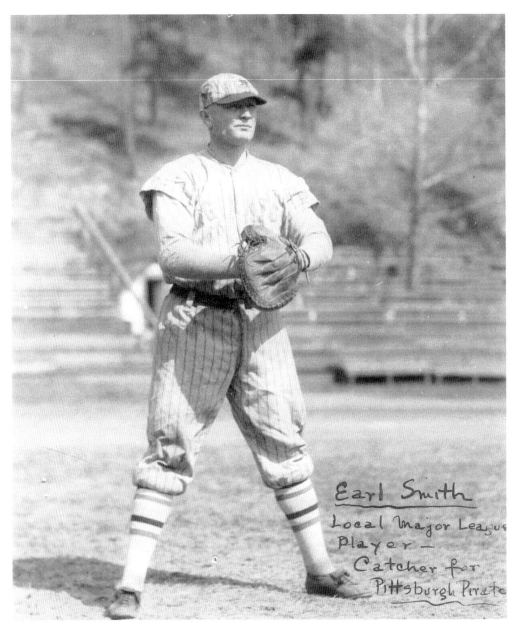

Earl "Oil" Smith, who grew up in Hot Springs and called it home, stands ready at Whittington Park around February 1922 or 1923 (after 1921, the typical newspaper scribe seldom referred to "McKee Field"). The gruff hind snatcher trained here with his New York Giants teammates between 1919 and 1923, prior to joining the Smoky City Buccaneers midway through the 1924 campaign. He ran a butcher shop in the off-season. (Courtesy of the Garland County Historical Society.)

Jack Quinn warms up at Whittington Park early in 1924. He was born in Slovakia (then part of Austria-Hungary) as Joannes Pajkos. The *Brooklyn Daily Eagle* of March 15, 1923, said that "Old Jack . . . broke into the league when Hector was a pup" and was "the best living example of perpetual motion." His final major-league game would be in 1933. (Courtesy of the Garland County Historical Society.)

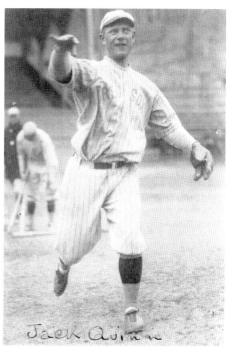

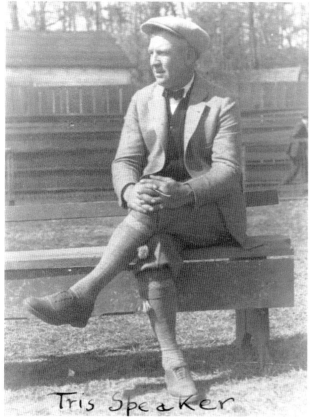

The Cleveland Indians' player/ manager Tris Speaker, fresh off a round of golf, finds a spot along the Whittington Park first-base line where he can scrutinize his players' progress. Alta Smith, publicity director for the Hot Springs Chamber of Commerce, was on hand to click the shutter sometime between 1924 and 1926. (Courtesy of the Garland County Historical Society.)

Whittington Park's warped hillside bleachers and 1910 grandstand are seen here from Whittington Avenue (near the Alligator Farm) around 1927. The amusement section located west of the field has obviously dwindled somewhat. (Courtesy of the Garland County Historical Society.)

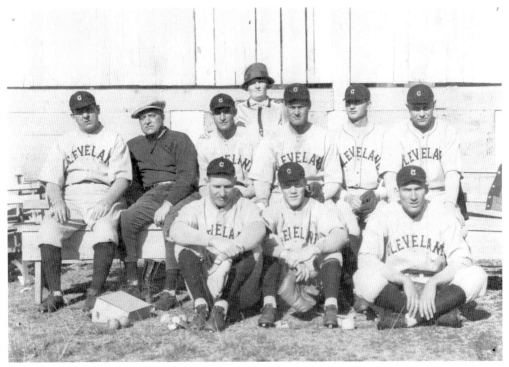

"Members of the Cleveland Indians [bask] in the sunshine" at Whittington Park on February 13, 1927, according to a press release from P&A Photos. Shown are, from left to right, (first row) pitcher Walter "Jake" Miller, pitcher Willis "Ace" Hudlin, and pitcher Carl "Sundown" Yowell; (second row) coach Harry Mathews, manager Jack McCallister, catcher Glenn Myatt, Mrs. Glenn Myatt, catcher Martin "Chick" Autry, pitcher Ollie Perry, and pitcher Emil "Dutch" Levsen. (Courtesy of the McKinzie Lambert Collection, Garland County Historical Society.)

AT THE BALLPARKS

Harry Mathews, Indians coach, lofts a fungo at Whittington Park in this c. February 1927 photograph. According to the February 16, 1927, Cleveland *Plain Dealer*, "Pitchers threw into a net with a slow, easy delivery, for unlimbering purposes, and then took a hand at grounders and flies, which [manager Jack] McCallister and Matty Matthews banged out for more than an hour." (Courtesy of the Garland County Historical Society.)

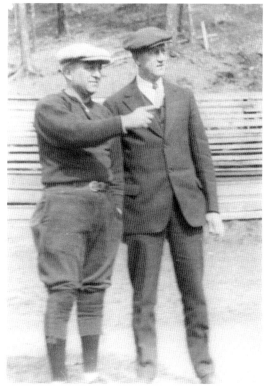

Manager Jack McCallister of Cleveland and future hall-of-fame pitcher Urban "Red" Faber of the Chicago White Sox watch the Indians work out at Whittington Park in February 1927. McCallister had been a scout and a coach in the Cleveland organization, but this would be his sole term as manager in the big arena. He skippered the 1909 Portsmouth (Ohio) Cobblers and the 1911 Akron Champs as well. (Courtesy of the Garland County Historical Society.)

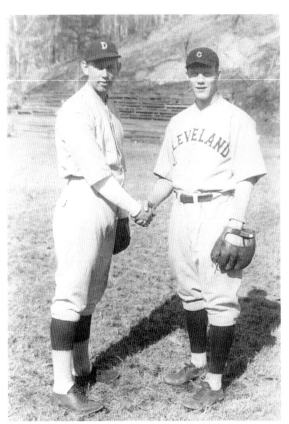

Spike Hunter (left), pitcher for the minor-league Dallas Steers, shakes hands with Indians hurler Willis Hudlin at Whittington Park in 1927. Although not from Arkansas, Hudlin kept a winter residence in the Spa City for years. Hunter was from Hot Springs and later played for the House of David and the Hot Springs Bathers. He owned a motel in Hot Springs as well, on Ouachita Street. (Courtesy of the National Baseball Hall of Fame.)

Tribe backstops Glenn Myatt (left) and Chick Autry toss the pill at Whittington Park in February 1927. The rickety bleachers would soon be removed. (Courtesy of the National Baseball Hall of Fame.)

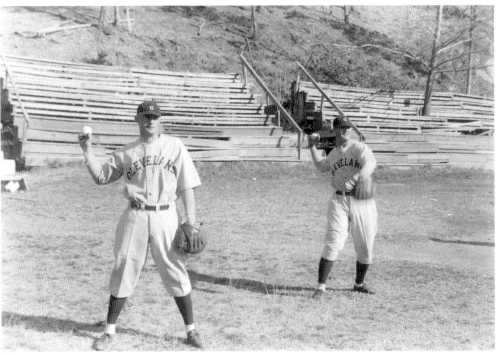

AT THE BALLPARKS

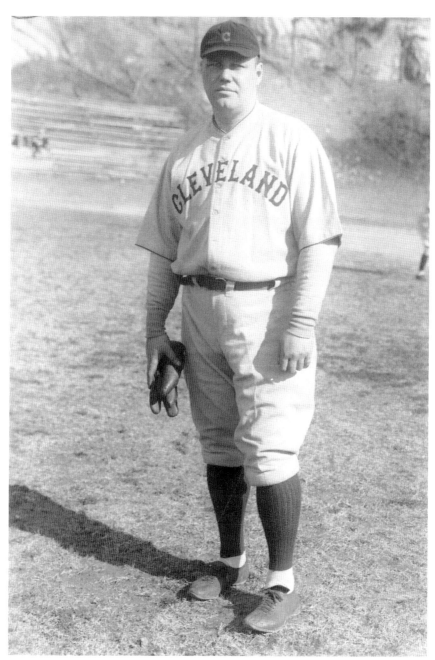

Garland Buckeye, shown at Whittington Park in February 1927, had just made his third trip to Hot Springs with an advance guard of Indians batterymen. He was, according to the February 22, 1926, *Augusta Chronicle*, "the biggest flinger in the majors" and was "walking his figure down to a mere 230" while he "boiled with hope" in thermal baths (although he found time to go fishing at Lake Catherine). The southpaw twirler also trained here with a party of Cleveland slabbers and grabbers in 1925. Buckeye is the great-grandfather of Drew and Stu Pomeranz, 21st-century hurlers with major-league experience. (Courtesy of the National Baseball Hall of Fame.)

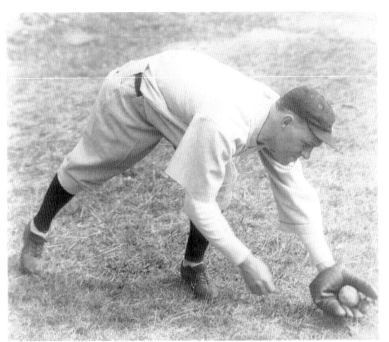

Lew Fonseca strikes a fielding pose at Whittington Park in 1927. He was an Indians infielder, but this February, "he acted, for the most part, as receiver because the club is short, but got in a good two-hour workout," according to the February 24 *Plain Dealer*. (Courtesy of the National Baseball Hall of Fame.)

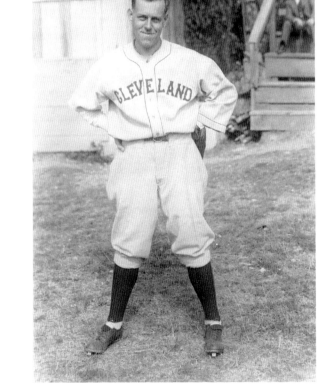

Lew Fonseca, seen here at Whittington Park in February 1927, would go on to win the 1929 American League batting title, manage the Chicago White Sox, and pioneer the use of cinema for baseball training, outreach, and entertainment. (Courtesy of the National Baseball Hall of Fame.)

AT THE BALLPARKS

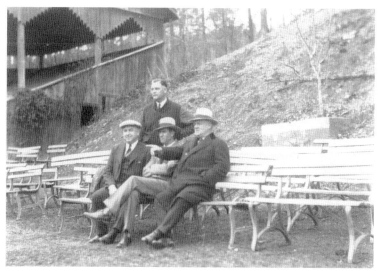

Pictured above, New York Giants officials watch the team train at Whittington Park in late February 1928. John McGraw, manager and vice president, is at far right. He was Giants manager from 1902 to 1932. Seated next to him is the dapper Eddie Brannick, assistant secretary. Brannick worked in various capacities for the club between 1905 and 1971. Seated to Brannick's right is James Tierney, the team secretary whom Brannick succeeded in 1936. Behind Tierney is Giants trainer Leonard "Doc" Knowles, who was ordered to trim the fat off catcher James "Shanty" Hogan in Hot Springs. Sandy Stiles wrote in the *St. Petersburg Times* of January 14, 1943, that this proved difficult, as "Hogan, a most engaging fellow, had induced his waiter to call pie 'spinach' and to say nothing at all about the cake." Pictured below, New York Giants manager John McGraw (right) and Giants coach Roger Bresnahan follow the work of their pitchers and catchers at Whittington Park in late February 1928. While here, McGraw named shortstop (and Arkansas native) Travis Jackson the new team captain: "[Jackson] is a heady, fighting ball player, and his steadiness under fire and his experience entitles him to the job. I know he'll make good." (Both, courtesy of the Garland County Historical Society.)

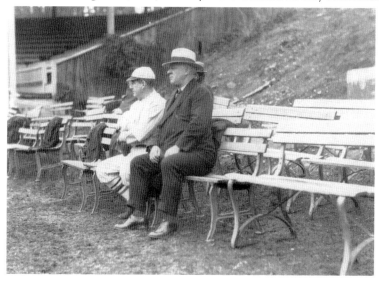

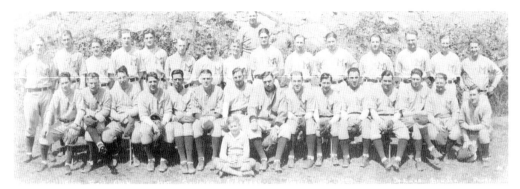

The minor-league Milwaukee Brewers are panoramically captured at Whittington Park on March 15, 1929. Manager Jack Lelivelt is seventh from left in the front row, behind the child. Born in the Netherlands, Lelivelt was raised in Chicago and became an outstanding player. Injuries diminished his major-league career, so he persevered in the minors as a player/manager, then as a full-time manager when he turned 40. His quiet, perceptive approach was compared to that of Walter Alston. In 1943, the Pacific Coast League Hall of Fame accepted him into its inaugural class. (Courtesy of Caleb Hardwick.)

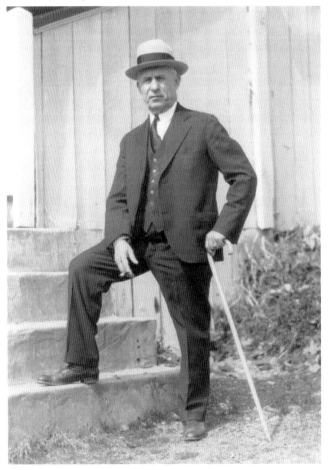

Michael H. "Mike" Sexton, boss of the minors, visits Whittington Park while vacationing in the Spa City around March 1930. While here, he endorsed Hot Springs as a training venue. A former police chief in Rock Island, Illinois, he was president of the National Association of Professional Baseball Leagues for over 20 years. (Courtesy of the Garland County Historical Society.)

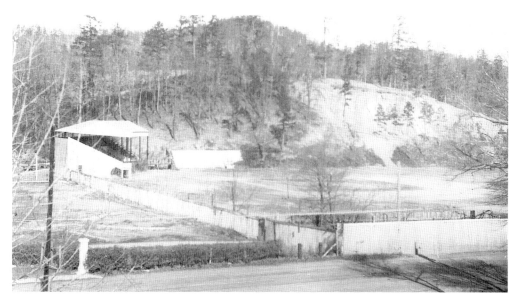

Whittington Park survived in reduced form, as seen here in January 1931. The grandstand had been rebuilt on a simpler scale after a 1930 fire, and much of the complex at left—which once included a shooting gallery and a postcard stall—disappeared. Note the recently poured concrete bleachers, remnants of which are visible today. (Courtesy of Jeff Carpenter.)

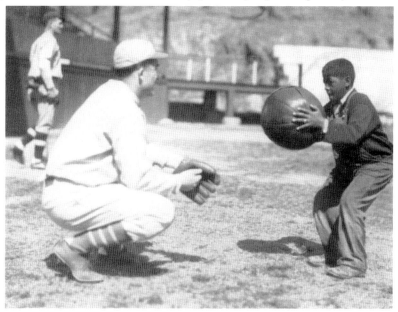

A lad "known by all the baseball players as Pudge" hefts a medicine ball with Al Simmons at Whittington Park on March 8, 1931. The Associated Press reported the following sad story: "Running backwards, the boy fell over his dog, breaking its leg. The boy wept a small waterfall for several minutes. 'I slept with him every night,' he sobbed. 'Never mind, Pudge,' Simmons said. 'I'll see that you get another hound.' Simmons has a large audience of schoolboys as soon as school is out every day." (Courtesy of the McKinzie Lambert Collection, Garland County Historical Society.)

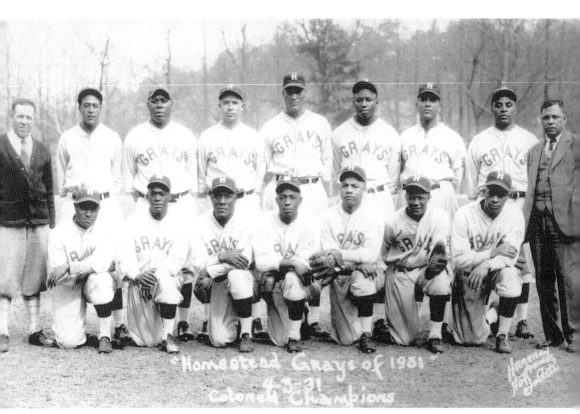

The Homestead Grays, of Pittsburgh, Pennsylvania, pose for a photograph at Fogel Field on April 3, 1931. Winners of the 1930 and 1931 Eastern championship challenge series, they are considered one of the all-time great teams. Cooperstown inductees include owner Cumberland Posey (standing at far left), Smokey Joe Williams (standing fifth from left), Josh Gibson (standing fourth from right), Oscar Charleston (standing second from right), and Jud Wilson (kneeling third from left). (Courtesy of the National Baseball Hall of Fame.)

AT THE BALLPARKS

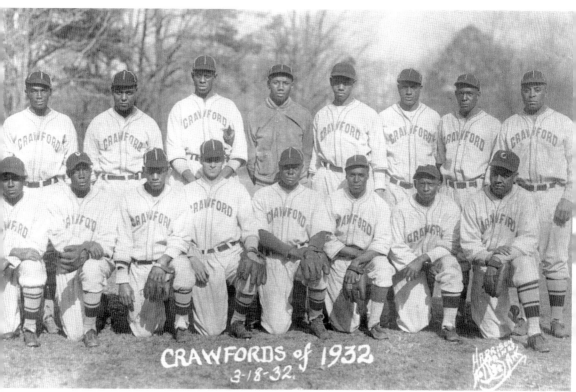

The Pittsburgh Crawfords trained at Fogel Field in 1932, at least a portion of the time. They also hiked and took the baths. Three hall of famers are seen here in the back row: Satchel Paige (third from left), Josh Gibson (fourth from left), and manager Oscar Charleston (far right). At age 80, Jimmie Crutchfield (kneeling, third from right) recalled, "We had only 10 days down there, but Oscar, he was one of those hard-driving guys from the old school, and he got us ready to play." Crutchfield added that "the players slept most nights on makeshift beds in a bath house." (Courtesy of the National Baseball Hall of Fame.)

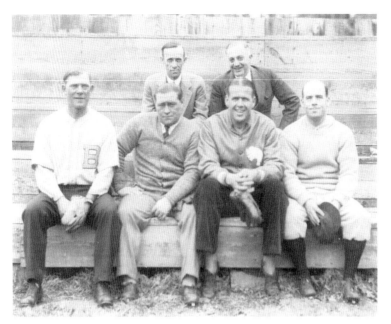

Seated at Whittington Park in February 1932 are, from left to right, (first row) Jack Quinn, Hack Wilson, George Earnshaw, and Benny Bengough; (second row) Johnny Evers and Ray Doan. Quinn, Wilson, Earnshaw, and Bengough were here to prime their bodies for spring training elsewhere. (Courtesy of the Garland County Historical Society.)

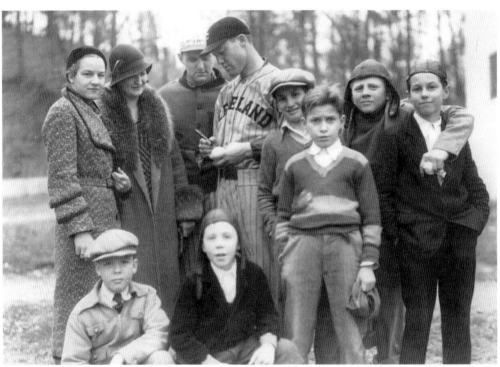

Willis Hudlin, pitcher for the Cleveland Indians, autographs a baseball at Whittington Park in February or March 1933, surrounded by fans. He had yet to sign a contract at this point, but was working out alongside the students in Ray Doan's baseball school and bathing at the Hale Bathhouse. Some of the children sport aviator hats, in fashion around this time. (Courtesy of the National Baseball Hall of Fame.)

AT THE BALLPARKS

Lon Warneke (left), Chicago Cubs hurler and hometown hero, meets Al Simmons (center) and Riggs Stephenson at Whittington Park on February 2, 1933. Simmons is wearing his Philadelphia Athletics jacket, although he had been sold to the Chicago White Sox four months before. Stephenson wears his Cubs cap and a sweater from his time with the Herb Hunter All-Stars team that toured Japan in 1922–1923. Simmons and Stephenson were getting into shape here prior to spring training, but this was the only day they exercised together. Stephenson had been bathing at the Hale for about a week and working out with Homer Hunter and Onais Sellers. In 1934, "Old Hoss" Stephenson would return to marry Alma Chadwick of Hot Springs. (Courtesy of the Garland County Historical Society.)

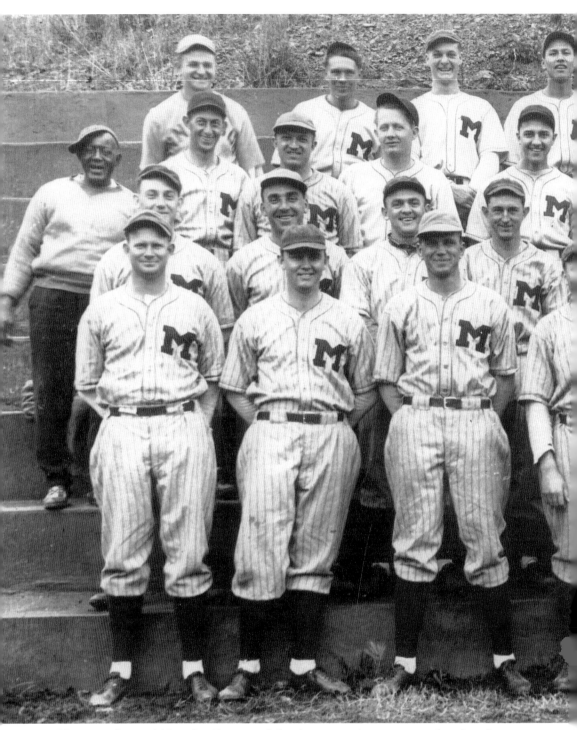

The minor-league Milwaukee Brewers of the American Association gather for a happy team photograph at Whittington Park in 1933. The man in the third row at far left is Harry "Doc" Buckner, their trainer between 1920 and 1938. Buckner, known as "Green River" in his salad days,

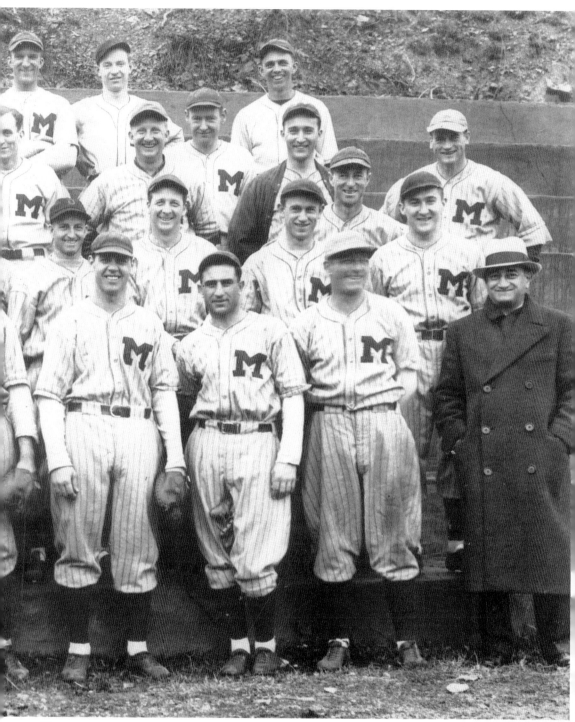

excelled as a player several decades before with the Columbia Giants, the Philadelphia Giants, the Cuban X-Giants, the Chicago Giants, and others. Club president Louis Nahin is in the first row at far right. (Courtesy of the National Baseball Hall of Fame.)

BASEBALL IN HOT SPRINGS

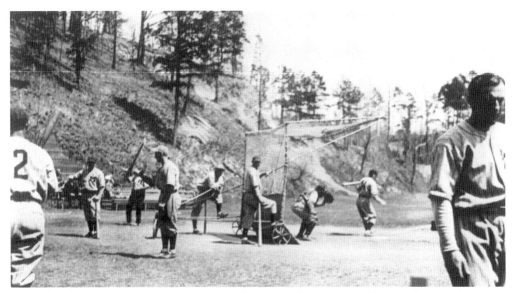

Several Milwaukee Brewers carry out vernal practice duties around home plate, while others relax at Whittington Park on March 27, 1933. Contrast the catcher's upright posture (near the batting cage) with the deeper crouch employed today. (Courtesy of the National Baseball Hall of Fame.)

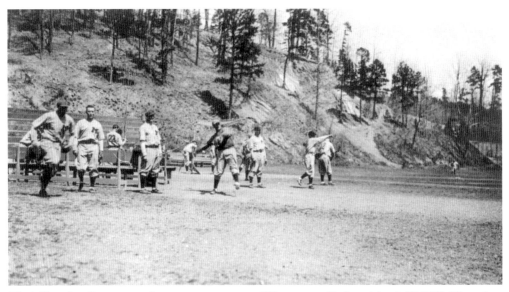

The Milwaukee Brewers conduct spring training at Whittington Park on March 27, 1933. Throwing, running, and batting are on simultaneous display. The player stationed to the right of third base awaits a fielding opportunity. (Courtesy of the National Baseball Hall of Fame.)

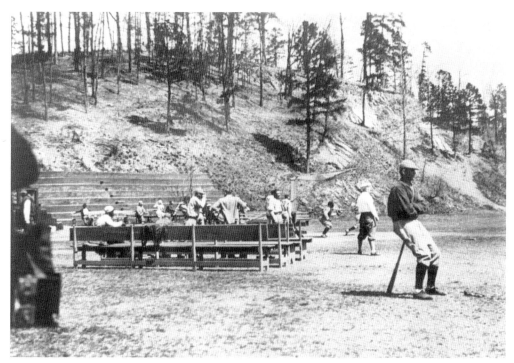

The Milwaukee Brewers work out at Whittington Park on March 27, 1933. One batter takes a healthy cut, while another demonstrates an alternative, and probably rather uncomfortable, use for the Louisville lumber. (Courtesy of the National Baseball Hall of Fame.)

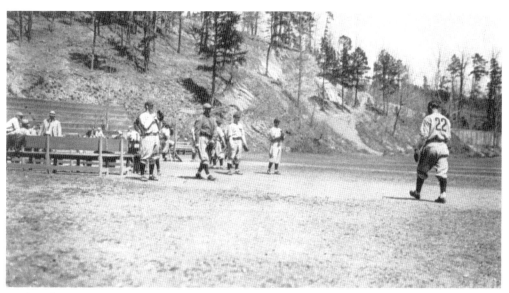

In this photograph, taken on March 27, 1933, the Brewers train at Whittington Park. Note the footpaths on the hillside; a gravel quarry or rock-crushing business once operated near the end of the right-hand trail. (Courtesy of the National Baseball Hall of Fame.)

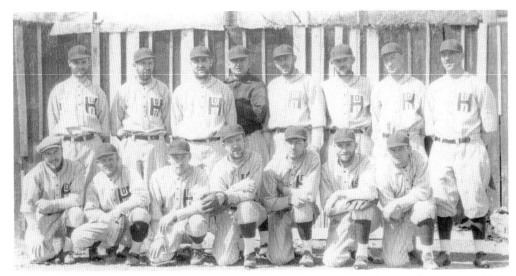

A religious sect called the House of David planted roots at Benton Harbor, Michigan, in 1903. In 1913, it started a baseball team, which was barnstorming across North America within a couple of years. Beards, unshorn locks, and other features made the team popular, so variants on the brand sprang up—some without the House's blessing. Here, one of these ensembles poses at Whittington Park around 1934. The players include true colony members and hired ringers. In the second row, fourth from left, is the manager, Grover Cleveland "Pete" Alexander. With Satchel Paige and Spike Hunter pitching for the Davids, this outfit won the *Denver Post* tournament (Little World Series of the West) in August 1934. (Courtesy of the Garland County Historical Society.)

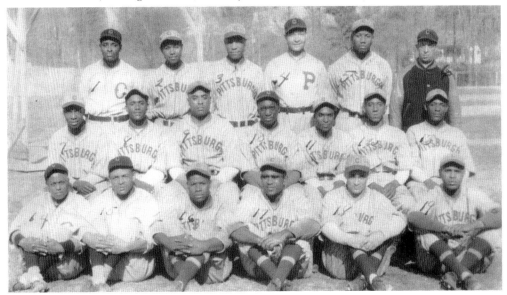

Another renowned club was the 1935 Pittsburgh Crawfords, shown here at Fogel Field. This photograph, taken in April, contains four hall of famers: James "Cool Papa" Bell (second row, far left), Oscar Charleston (second row, third from left), William "Judy" Johnson (third row, second from left), and Josh Gibson (third row, second from right). (Courtesy of the National Baseball Hall of Fame.)

AT THE BALLPARKS

Harold "Hy" Vandenberg, pitcher for the New York Giants, delivers the orb at Whittington Park in February 1938. The park was renamed Ban Johnson Field in 1935. Vandenberg and his battery colleagues, here primarily for baths and roadwork under the eye of manager Bill Terry, would soon be off to regular training camp at Baton Rouge. (Courtesy of the McKinzie Lambert Collection, Garland County Historical Society.)

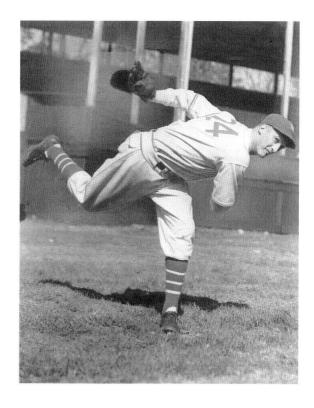

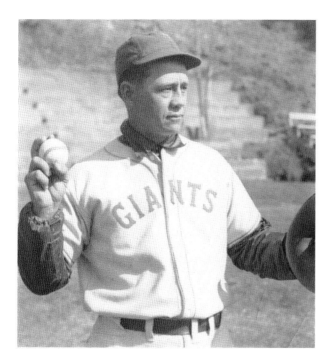

The New York Giants' Gus Mancuso, with apple and mitt, is about to knock some winter rust off his "peg 'em out" style at Ban Johnson Field around February 1938. The Giants had obtained him from the St. Louis Cardinals in 1932, but the Gotham pilot, Bill Terry, now wanted the highly respected signal caller to back up first-string catcher Harry Danning. Terry admitted trouble in the February 15 *Canton Repository*: "I'm trying to trade Mancuso because he can't stand playing second fiddle." On December 6, 1938, Mancuso became a Chicago Cub. (Courtesy of the Garland County Historical Society.)

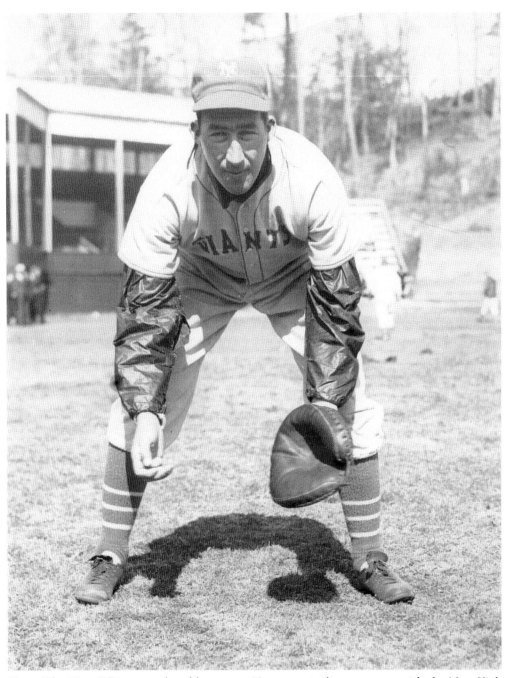

Harry "the Horse" Danning played his entire 10-year major-league career with the New York Giants. Here, he seems ready to take a throw at Ban Johnson Field in February 1938. Nicknamed for a Damon Runyon character later incorporated into *Guys and Dolls*, the catcher was a four-time all-star. (Courtesy of the Garland County Historical Society.)

AWAY FROM
THE DIAMONDS

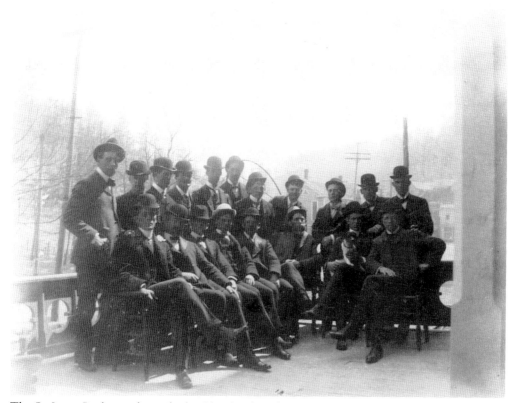

The St. Louis Perfectos, formerly the Cleveland Spiders, relax on the porch of the Majestic Hotel in 1900. The team name would change again in a few months, to the Cardinals. (Courtesy of the Garland County Historical Society.)

Honus Wagner (left) of the Pittsburg Pirates hams it up at Happy Hollow with an unidentified pal around 1906. Happy Hollow, located on Fountain Street, offered all kinds of tourist attractions, including gag-photo studios. On March 18, 1906, according to the *Pittsburg Daily Post*, "Wagner chaperoned a party of young players on a tour of Happy Hollow." The paper also reported that, after a downpour on March 26, "the contingent from California and Carnegie [Pennsylvania] had their 'pictures took' in several group poses in Happy Hollow." (Courtesy of the McKinzie Lambert Collection, Garland County Historical Society.)

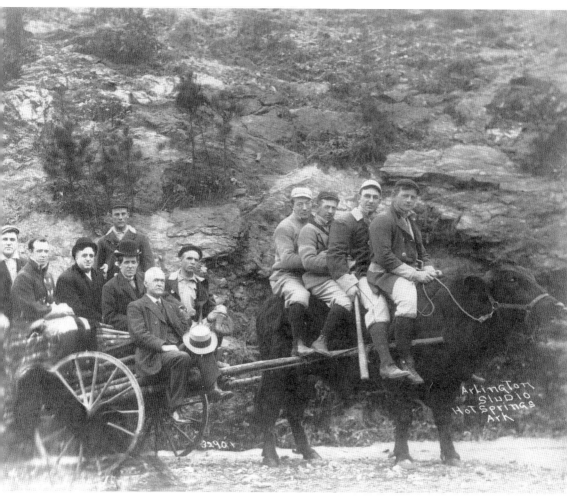

The Highlanders (later called the Yankees) and guests pose for a souvenir photograph, possibly at Happy Hollow, in February or March 1908. From left to right are Al Orth, Bill Hogg, C.C. Spink (of the *Sporting News*), Norman "The Tabasco Kid" (later shortened to "Kid") Elberfield, Michael J. Regan (a Royal Rooter for the Red Sox), W.R. Joyner (Atlanta mayor and president of the Atlanta Crackers team), New York manager Clark "The Old Fox" Griffith, John "Red" Kleinow, William "Wee Willie" Keeler, Jake Stahl, and Jack Chesbro. (Courtesy of the National Baseball Hall of Fame.)

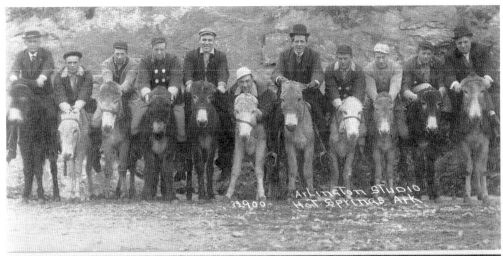

The Highlanders (and the same guests) get even campier at the same location in February or March 1908. Holding the ears of the patient donkeys are, from left to right, Joyner, Griffith, Keeler, Hogg, Orth, Stahl, Regan, Elberfield, Kleinow, Chesbro, and Spink. (Courtesy of the National Baseball Hall of Fame.)

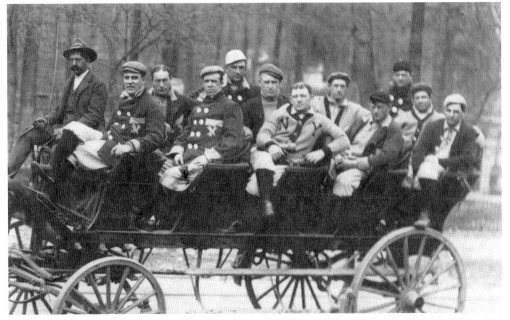

The New York Highlanders enjoy a carriage ride in Hot Springs in February or March 1908. The Boston Red Sox would purchase Jake Stahl (fifth from left) in July. (Courtesy of the National Baseball Hall of Fame.)

AWAY FROM THE DIAMONDS

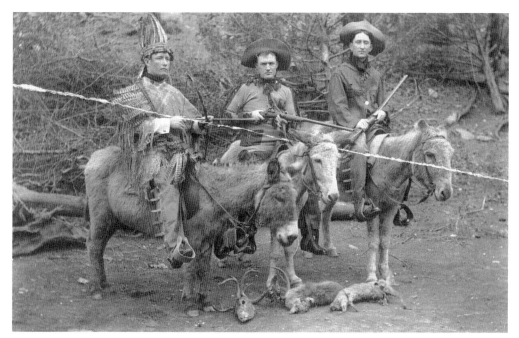

From left to right, Red Sox catchers Thomas "Bunny" Madden, Bill Carrigan, and Pat Donahue mug for the lens at Happy Hollow in 1909 or 1910. This popular Fountain Street business was stocked with props. (Courtesy of the McGreevey Collection, Boston Public Library.)

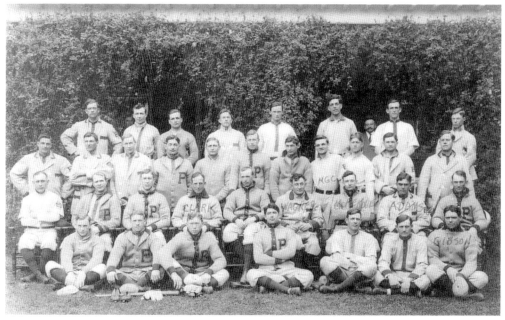

The Pittsburg Pirates pose for a team photograph at the Eastman Hotel, where they were staying while they trained in early 1911. Some players are wearing older uniform components, with the "Pittsburg Baseball Club" (PBC) logo on the left sleeve. (Courtesy of Caleb Hardwick.)

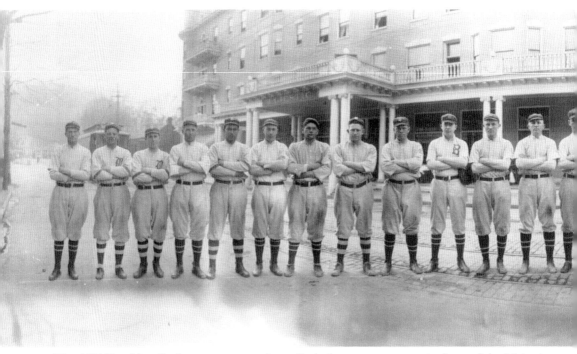

The 1911 Brooklyn Dodgers are captured in a Park Avenue panorama in front of the Majestic Hotel (which burned down in 2014). The Trolley Dodgers, frequently called the Superbas in that era, earned seventh place in the upcoming National League campaign. Note the chalk line

AWAY FROM THE DIAMONDS

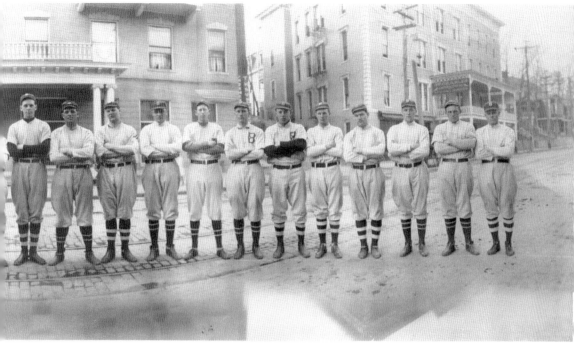

on the brick pavers, perhaps drawn by the photographer so the players would line up correctly. An electric trolley is in the background. (Courtesy of the George Grantham Bain Collection, Library of Congress.)

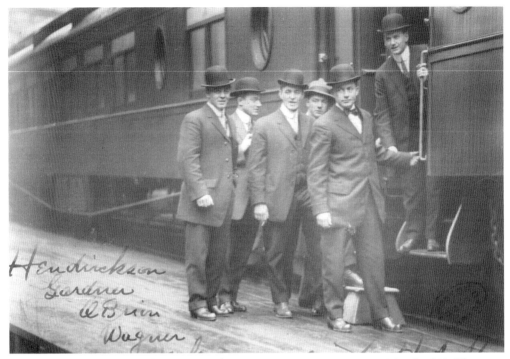

Members of the Boston Red Sox survey the Hot Springs train station in March 1912. They are, from left to right, Olaf "Swede" Henriksen, Larry Gardner, Thomas "Buck" O'Brien, Charles "Heinie" Wagner (no kin to Honus), Steve Yerkes, and Hugh "Corns" Bradley. (Courtesy of the McGreevey Collection, Boston Public Library.)

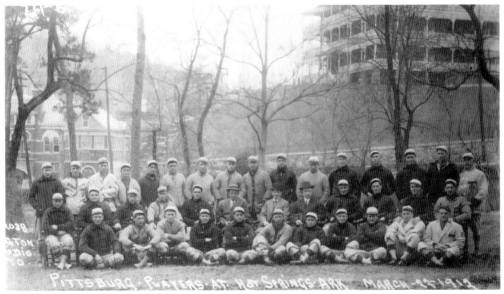

The 1912 Pirates assemble for a photograph in front of the Eastman Hotel. Behind them, across Reserve Avenue, are the Imperial Bath House (left) and the Army-Navy Hospital's first administration building (right). (Courtesy of the George Grantham Bain Collection, Library of Congress.)

AWAY FROM THE DIAMONDS

The "Grey Eagle" rides a stuffed reptile at the Alligator Farm around 1912. Boston Red Sox centerfielder Tris Speaker seems not to have had much gray hair at this point, but he would be "saddled" with the nickname by 1914. (Courtesy of the Garland County Historical Society.)

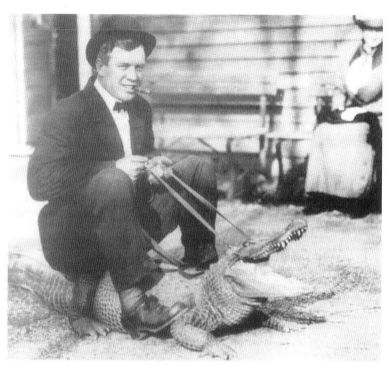

Honus Wagner offers canned sustenance to an entrance "statue" at the Alligator Farm around 1913. The *Pittsburgh Post* reported that March 30, 1913, "was another rest day in the Pirate camp . . . several parties of strollers, however, visited the alligator and ostrich farms." Whether he joined that particular trip to the attraction is unknown, but Wagner did go fishing that day on the Ouachita River. (Courtesy of the McKinzie Lambert Collection, Garland County Historical Society.)

Several members of the Red Sox pose with their donkeys in front of the Majestic Hotel, after or before a ride, probably on March 21, 1921. Players include John "Shano" Collins, on the donkey at right, and Cliff Brady, to the right of the same animal. According to Ed Cunningham of the *Boston Herald*, "Several of the players went on a mountain climb this afternoon on burros and a little excitement was caused when John Campbell, a veteran winter leaguer of Boston [a fan who tagged along with the team at spring training], was gently caressed by a bull, which caught John squarely while [he] was not looking." (Courtesy of the McKinzie Lambert Collection, Garland County Historical Society.)

Alta Smith's handwritten note on the back of this photograph reads, "Miss Bernice Huston, daughter of Col. T.L. Huston, of New York City, former half-owner of Yankees, meets Mrs. Weshunka Pryor, of Hominy, Okla., niece of Chief Black Dog—at her left is Mrs. Arthur Bonnecastle, of Pawhuska, Okla., widow of the chief who led the Osages." The picture was taken at Hot Springs in February or March 1924, probably at the country club. (Courtesy of the Garland County Historical Society.)

AWAY FROM THE DIAMONDS

Babe Ruth poses at Oaklawn Track in February or March 1921. In 1924, he rode a shaggy mountain pony on the Hot Springs National Park bridle paths. During his final visit here, in 1925, he weighed 245 pounds. The *New Orleans Times-Picayune* of February 26 reported, "Ruth . . . hired a diminutive mount and cantered over many miles of Ozark trails. Even Babe admitted, however, that the equestrian mode of exercise was probably more strenuous on the horse than himself." (Courtesy of the Garland County Historical Society.)

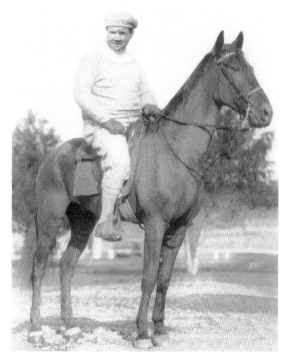

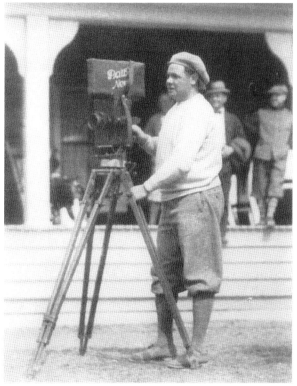

George "Babe" Ruth tries his hand at journalism with a newsreel company's motion-picture camera in the early 1920s. A few bystanders enjoy the scene, possibly at the Hot Springs Golf and Country Club. (Courtesy of the Garland County Historical Society.)

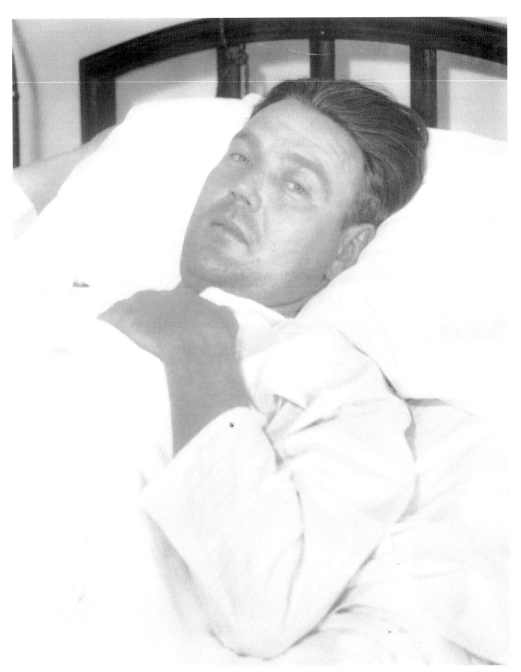

George "The Danish Viking" Pipgras, star New York Yankees pitcher, rests at the Ozark Sanitarium in Hot Springs after an emergency appendectomy on February 11, 1931. He had recently arrived at the Federal Spa to get in trim for spring training camp. His local physician, Dr. W.V. Laws, said Pipgras "would not be able to indulge in any strenuous exercise for about four months." Pipgras still had a winning season, and the next year, he notched the victory in Babe Ruth's "called shot" World Series game against the Cubs. (Courtesy of the Garland County Historical Society.)

AWAY FROM THE DIAMONDS

Jack Quinn stands with a youngster in downtown Hot Springs around 1933. Quinn pitched for several major-league teams. Renowned for his baseball longevity, his career lasted through his 50th year. He was one of the last legal spitballers. (Courtesy of the National Baseball Hall of Fame.)

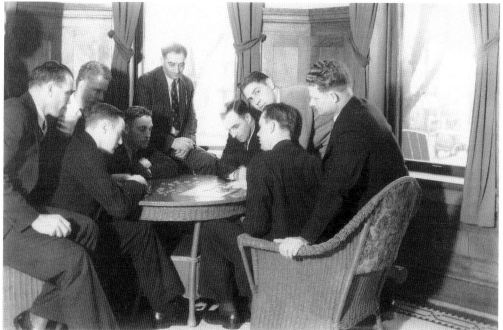

Several members of the Milwaukee Brewers assemble a jigsaw puzzle at a local hotel or bathhouse. They were less successful at putting the pieces together for their season, as these 1933 "Suds Boys" finished 20 games under .500. Louis Nahin, club president, is at center. Manager Frank O'Rourke (fourth from right), an Ontario native, was inducted into the Canadian Baseball Hall of Fame in 1996. (Courtesy of the National Baseball Hall of Fame.)

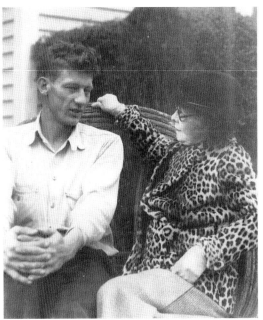

Lon Warneke visits with Marie Taylor Spink, widow of Charles Claude Spink, at his house in Hot Springs on December 8, 1933. Gerald Holland wrote for *Sports Illustrated* in 1961 that Marie Spink, "a five-foot fireball who weighed no more than 100 pounds, was a great character in her own right. She worked at her desk at the *Sporting News* almost until the day of her death. Like her son [J.G. Taylor Spink], she could swear like a Marine sergeant, and old hands recall memorable occasions when mother and son stood together, roaring their oaths and shaking their fists—not at each other—but at some injustice done to baseball or the *Sporting News*." (McKinzie Lambert Collection, Garland County Historical Society.)

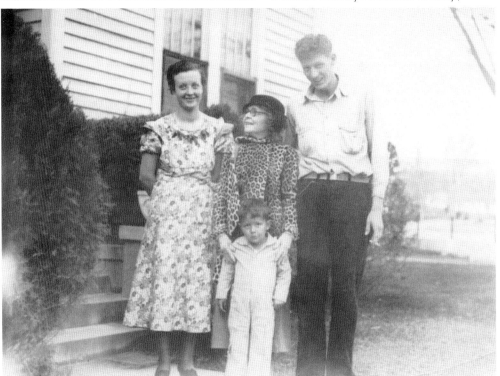

Lon Warneke poses with Marie Spink (center), his wife, Charlyne, and an unidentified boy at his winter home in Hot Springs on December 8, 1933. Spink, age 62 here, declared that the baths "keep me young and full of pep." (Courtesy of the McKinzie Lambert Collection, Garland County Historical Society.)

AWAY FROM THE DIAMONDS

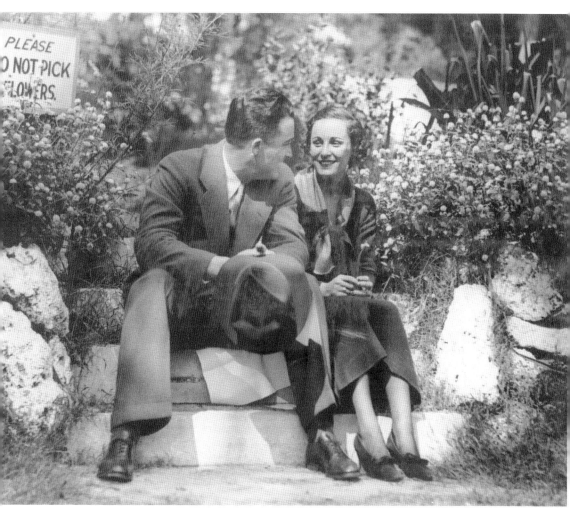

"Bucketfoot Al" Simmons and his wife, Doris, are surrounded by tempting flowers in October 1934. They were home in Hot Springs for a month, having married secretly in August in Chicago. Simmons gave his more proper name, Aloysius Harry Szymanski, on the marriage license. Newspapers indicate that the couple took a brief honeymoon in Wisconsin immediately after the wedding while Simmons was out of the White Sox lineup due to a finger injury. In late 1934 and early 1935, however, they honeymooned more extensively, in Honolulu and California. (Courtesy of the McKinzie Lambert Collection, Garland County Historical Society.)

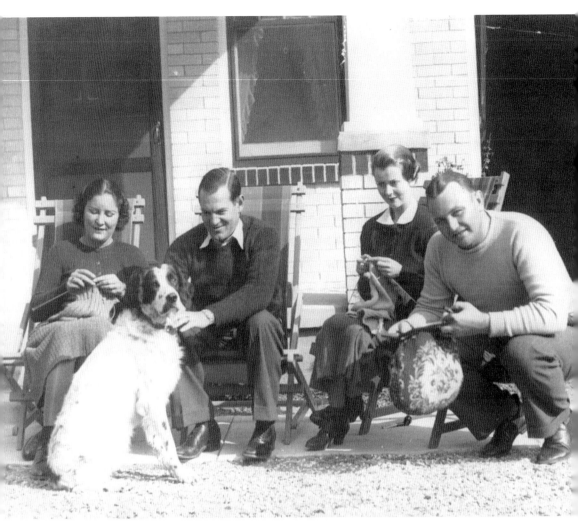

Cubs infielder Woody English (second from left), Cardinals pitcher Lyle "Bud" Tinning (far right), their wives, and a dog enjoy domestic life at their Hot Springs cottages in January or early February 1935. Mrs. Tinning is at left. These "diamond stars look pleased—because sweaters are being made for them," according to the press release that accompanied the photograph. Tinning had lost 20 pounds in two weeks as a result of golfing and baths. After six weeks here, English returned to Chicago 10 pounds heavier, as he had wanted. (Courtesy of the Garland County Historical Society.)

AWAY FROM THE DIAMONDS

Arkansas-born Jay Hanna "Dizzy" Dean and his wife, Patricia Nash Dean, originally from Mississippi, savor a slice of February 1935 at Oaklawn Park, with race horse Protractor. The jockey is J. Burrill. (Courtesy of the Garland County Historical Society.)

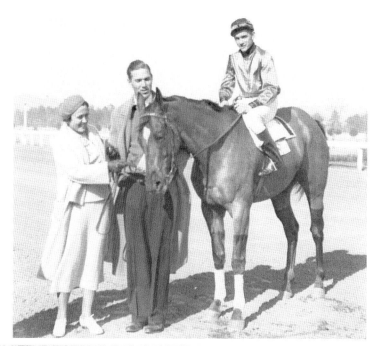

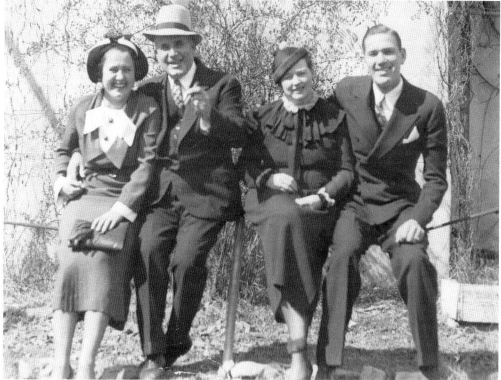

Dizzy and Patricia Dean (right) sit next to an older couple, probably in Hot Springs National Park. The photograph may have been taken in the mid-1930s, while Dean was in Hot Springs to teach at Ray Doan's All-Star Baseball School. (Courtesy of the Garland County Historical Society.)

Dizzy Dean playfully nocks an arrow on a bowstring near the open springs located behind the Maurice Bathhouse at Hot Springs National Park. His aim is southward, as if targeting the Stevens Balustrade. This photograph was taken in the mid-1930s. (Courtesy of the Garland County Historical Society.)

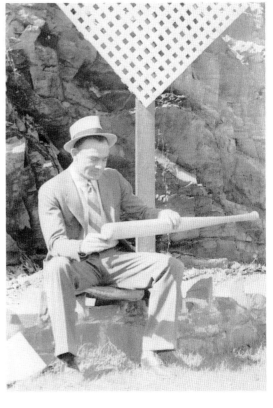

Wally Moses of the Philadelphia Athletics examines a bat with signatures of diamond stars in February 1936. "Wally said he's no hold out and everything is rosy," according to the accompanying wire blurb from Hot Springs. (Courtesy of the Garland County Historical Society.)

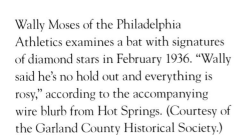

AWAY FROM THE DIAMONDS

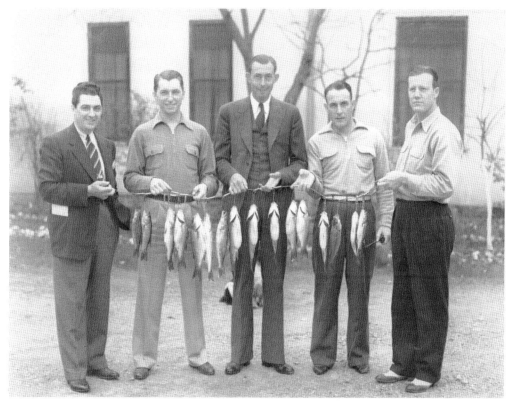

Pitchers who have been doing a little catching display their fish on a stringer at Willis Hudlin's Lake Hamilton resort on February 11, 1938. From left to right are Earl Whitehill, Mel Harder, Cliff Melton, Johnny Allen, and Willis Hudlin. (Courtesy of the Garland County Historical Society.)

Pitchers Carl Hubbell (left) and Cliff Melton (right) congratulate teammate Gus Mancuso for signing his contract with the New York Giants in February 1938. The catcher affixed his John Hancock at Hot Springs on February 18, in the presence of manager Bill Terry. (Courtesy of the Garland County Historical Society.)

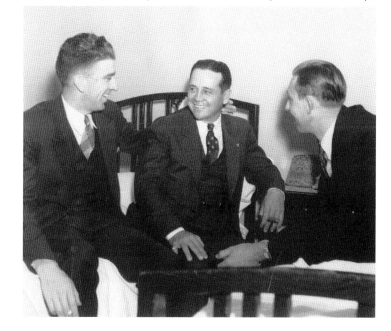

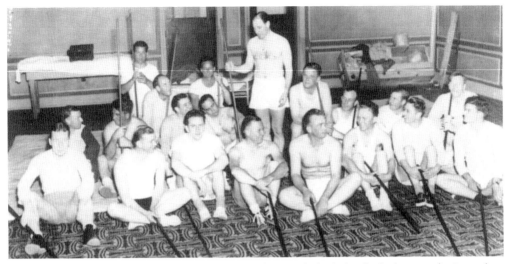

Player/manager Leo Durocher instructs his 1939 Dodgers with the help of calisthenic rods. According to the *Brooklyn Eagle* of February 16, "The Lip" Durocher's conditioning schedule had this for 9:15 every morning: "Report in bathing trunks, sweatshirts and rubber-soled shoes, to a large room, provided by the Eastman Hotel, where for a half-hour Prof. McCormick [Ed McCormick of Artie McGovern's New York gymnasium] will conduct calisthenics." Then, after a nine-mile hike and no lunch, it was back to calisthenics, throwing and catching on the hotel lawn, and, finally, the baths, dinner, and bed. (Courtesy of the Garland County Historical Society.)

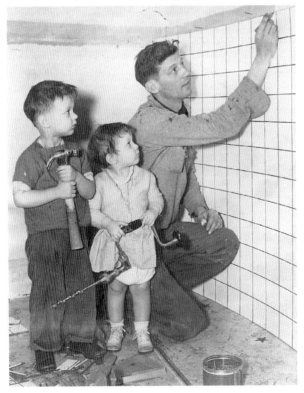

This Associated Press photograph dated January 15, 1940, was sent with the caption, "A two-year contract signed last spring leaves Lon Warneke, St. Louis Cardinals pitcher, without the worries some players experience about this time of the year. Lon is remodeling his bathroom with plenty of help from his children, Charles and Lonnie Pat, in his home in Hot Springs, Ark." Lonnie remembers her dad telling her to hold the nails to keep them warm. (Courtesy of the McKinzie Lambert Collection, Garland County Historical Society.)

AWAY FROM THE DIAMONDS

BATHING AND HIKING

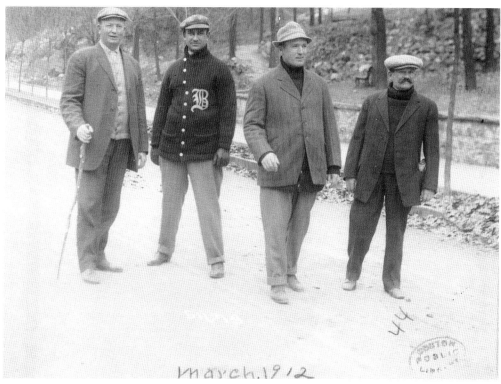

March. 1912

A party of Boston Red Sox players and friends hike on Fountain Street in early March 1912. They are, from left to right, Denton T. "Cy" Young (recently retired), Jake Stahl, Bill Carrigan, and Michael T. "Nuf Ced" McGreevey (leader of the Royal Rooters). In addition to exercising, they may also have been aiding in the search for a suspect who had just fatally shot a cook at the Arlington Hotel kitchen. (Courtesy of the McGreevey Collection, Boston Public Library.)

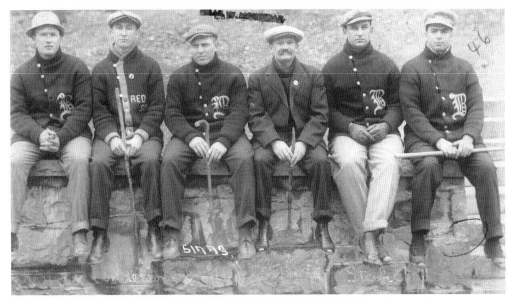

Sitting on a rock wall near the present-day Fountain Trail are six members of the Red Sox contingent that reached town before the majority of their comrades. Posing here in early March 1912 are, from left to right, Bill Carrigan, Fred Anderson, Clyde Engle, Michael T. McGreevey, Jake Stahl, and Charley "Sea Lion" Hall. (Courtesy of the McGreevey Collection, Boston Public Library.)

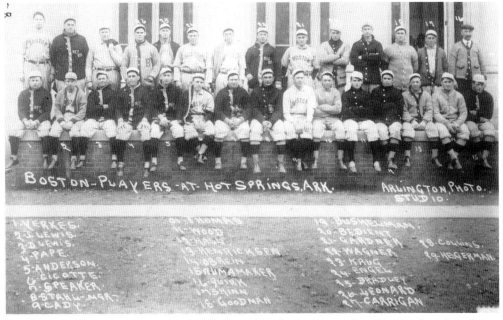

Judging by the clothes and the hands folded and hands in pockets, these Boston Red Sox players and hopefuls would rather be inside the pristine Buckstaff Bath House (built 1912), taking thermal baths, than outside with the photographer. This team, seen here in March 1912, would surpass 100 victories and win the World Series. (Courtesy of the George Grantham Bain Collection, Library of Congress.)

BATHING AND HIKING

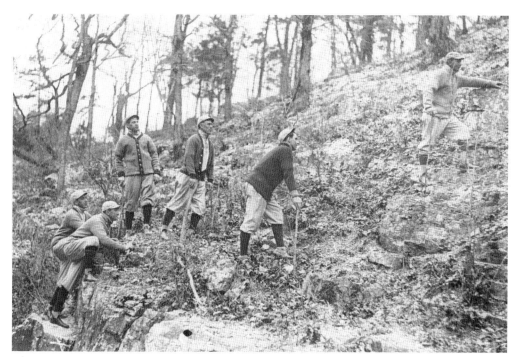

The 1912 Red Sox put in their share of the open-air up-and-down. Seen here in late March are, from left to right, Marty Krug, George "Duffy" Lewis, Harry Hooper, Larry Gardner, and possibly Howard "Smoky Joe" Wood and Chester "Pinch" Thomas. They clearly need their hiking sticks, as they climb without the convenience of a trail. (Courtesy of the McGreevey Collection, Boston Public Library.)

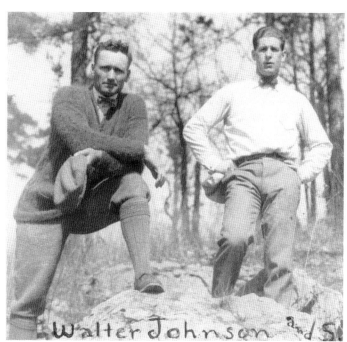

Walter "The Big Train" (or "Barney") Johnson (left) and player/manager Stanley "Bucky" Harris of the Washington Senators hike in the mountains, probably within Hot Springs National Park, in late February or early March 1924. This was Harris's first opportunity as a manager; his finale as a field maestro would be in 1956 with Detroit. (Courtesy of the Garland County Historical Society.)

Walter Johnson and S...

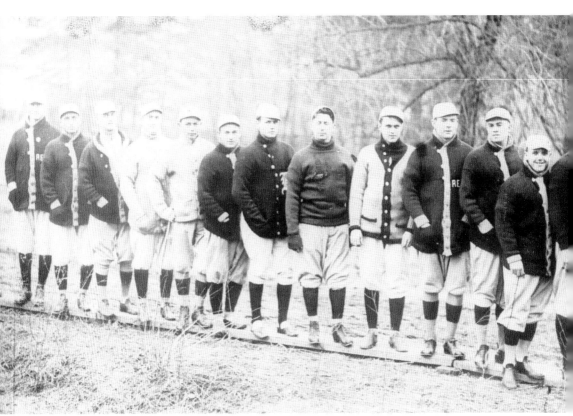

Somewhere in Garland County, the Boston Americans pose for "half a panoramic" photograph. These players illustrate how chilly spring weather could be in Hot Springs. Note the lack of cleats on their shoes; these guys were not about to play ball. The high temperature that day was 42 degrees. (Courtesy of the George Grantham Bain Collection, Library of Congress.)

BATHING AND HIKING

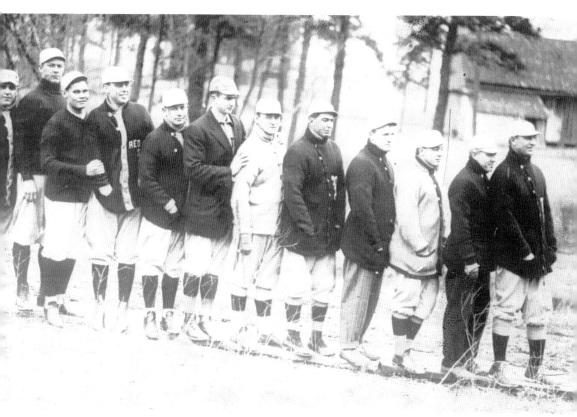

Here is the matching half of the panorama shown on the previous page. A few altered facial expressions here prove that this photograph was taken a few minutes earlier or later than the accompanying picture. On March 22, 1912, according to the *Boston Journal*, "Manager Jake Stahl had his squad out on the road for a long walk in the forenoon, and after lunch the boys bundled up in their sweaters and followed him on a ten-mile hike over the mountains." (Courtesy of the George Grantham Bain Collection, Library of Congress.)

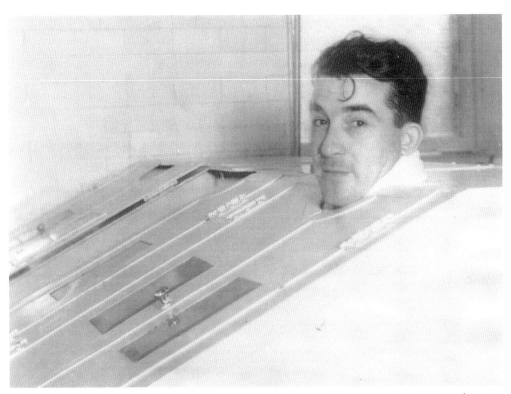

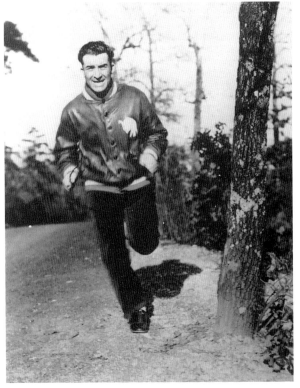

Al Simmons gets a jump on his winter conditioning in a Spa City steam cabinet on November 16, 1932. He wanted to lose 20 pounds before reporting to his new team, the Chicago White Sox, the next spring. (Courtesy of the McKinzie Lambert Collection, Garland County Historical Society.)

Al Simmons jogs on a mountain drive, possibly in early 1933, after returning from his home in Milwaukee. He had forsaken his second love, golf, because of an injured hand. (Courtesy of the McKinzie Lambert Collection, Garland County Historical Society.)

BATHING AND HIKING

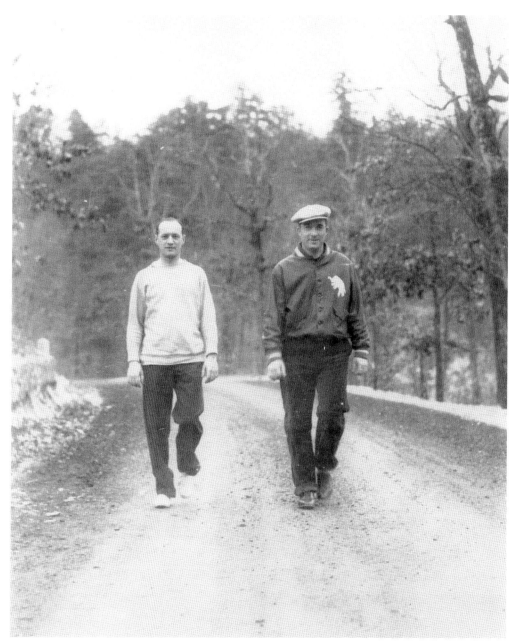

Al Simmons (right) and a buddy walk a scenic drive on Hot Springs Mountain or North Mountain, in Hot Springs National Park. Note the monument on the inside turn; it dated from 1914 and marked a point along one of four Oertel routes laid out for people wanting "graduated exercise." Each route had a different level of difficulty, and a map was available. It even had space for a doctor to write instructions. Dr. Oertel was a Bavarian physician who originated the concept. By 1933 the significance of the markers appears to have been largely forgotten, but the road's gentle grade still made for healthy exercise if hikers were alert to automobile hazards. This photograph was taken in early 1933. (Courtesy of the Garland County Historical Society.)

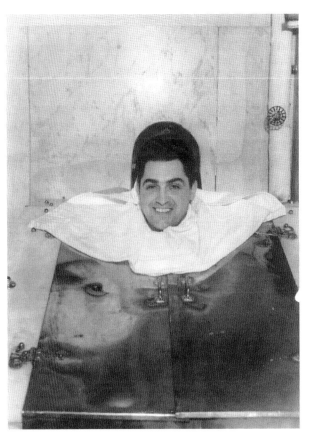

Earl Whitehill prepares to sweat in a head-out vapor cabinet in February 1933. He frequently trained in Hot Springs, but this time, it was for a different team. He had just been traded to the Washington Senators. (Courtesy of the National Park Service, Hot Springs National Park.)

In October or November 1934, Detroit Tigers catcher and manager Gordon "Mickey" Cochrane finds himself "in hot water" for the bruises he incurred during the World Series a few weeks before. He was staying in Hot Springs as the guest of his former teammate, Al Simmons. (Courtesy of the National Park Service, Hot Springs National Park.)

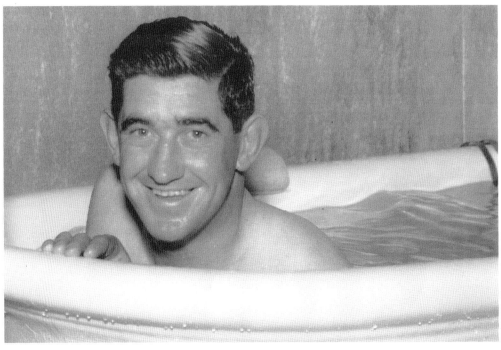

BATHING AND HIKING

Jay Hanna "Dizzy" Dean grins in his thermal bath at Uncle Sam's Tub City sometime between 1934 and 1938. He was in town to teach at Ray Doan's baseball school. (Courtesy of the Garland County Historical Society.)

Paul "Daffy" Dean, younger brother of Dizzy and a fellow Cards hurler, peers over the rim of his tub at a Hot Springs bathhouse, perhaps in early February 1935. Paul Dean owned the minor-league Hot Springs Bathers in the 1950s. He was here in 1935 to instruct at the baseball school. (Courtesy of the Garland County Historical Society.)

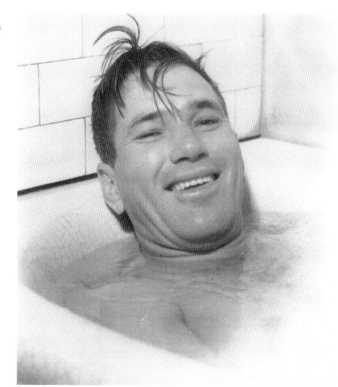

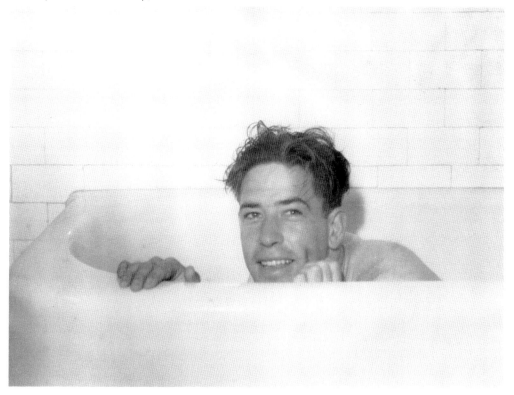

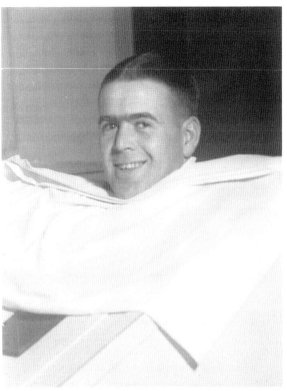

The Philadelphia Athletics' manager, Connie Mack (whose real name was Cornelius McGillicuddy), often allowed pitcher George "Moose" Earnshaw to condition at Hot Springs and report late to Florida spring training. Earnshaw is shown here in a head-out vapor cabinet in early 1935. (Courtesy of the National Park Service, Hot Springs National Park.)

Detroit pitcher Tommy Bridges waits for a bath attendant to fill his tub with thermal water in early 1935 or early 1936. Most players wanted to lose weight at Hot Springs, but he was taking a three-week course of baths with the opposite hope. His big-league career lasted 17 years, all with the Tigers. (Courtesy of the Garland County Historical Society.)

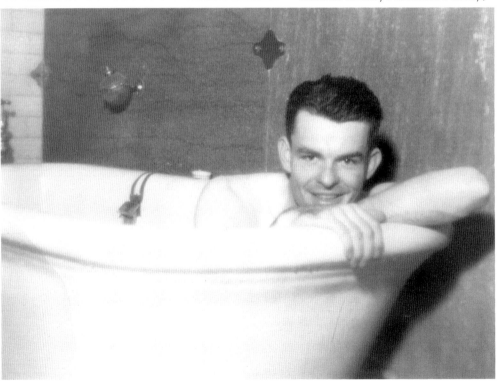

BATHING AND HIKING

Robert Moses "Lefty" Grove looks delighted to once again sit in a steam cabinet. Grove, seen here in the 1930s, believed that the bath and massage treatments at Hot Springs helped revive his pitching arm after it had twice "gone dead." (Courtesy of the McKinzie Lambert Collection, Garland County Historical Society.)

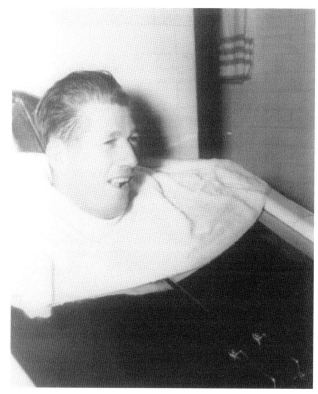

Lefty Grove appears pensive in the cooling room after his bath routine in the 1930s. Perhaps he was imagining the massage he would soon receive. (Courtesy of the McKinzie Lambert Collection, Garland County Historical Society.)

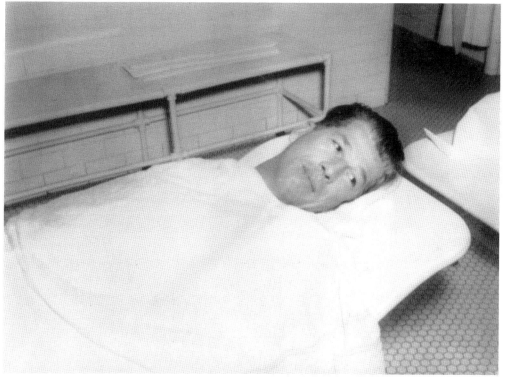

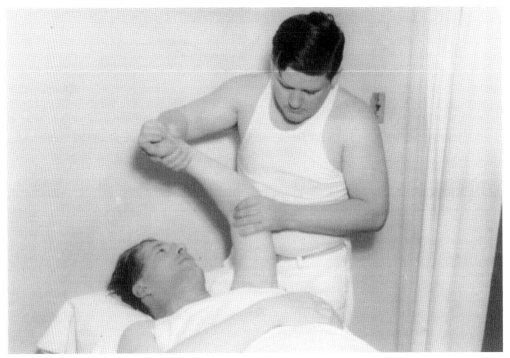

A masseur works on Lefty Grove's pitching arm in the 1930s. "Old Mose" got 300 major-league wins out of that soup bone. (Courtesy of the McKinzie Lambert Collection, Garland County Historical Society.)

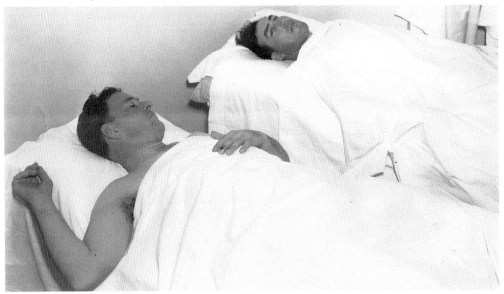

Mel Ott (left) and Harry Danning of the New York Giants relax in the cooling room after their baths in late February or early March 1939. "Master Melvin," turning 30 on March 2, was already entering his 14th major-league season. (Courtesy of the McKinzie Lambert Collection, Garland County Historical Society.)

BATHING AND HIKING

Larry Doby of the Cleveland Indians, the first African American player in the American League, gets a massage at Hot Springs in February 1954. The photograph would have been taken at the bathhouse of either the National Baptist or the Pythian, hotels on Malvern Avenue. (Courtesy of the McKinzie Lambert Collection, Garland County Historical Society.)

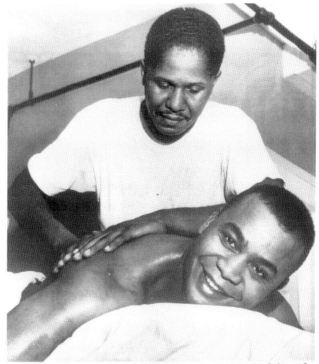

CAP17-2/16-HOT SPRINGS,ARK.:An attendant gives Larry Doby, of the Cleveland Indians a soothing rub-down after a tiring work-out in this resort city where Doby is getting in shape for the coming season. UNITED PRESS TELEPHOTO jk

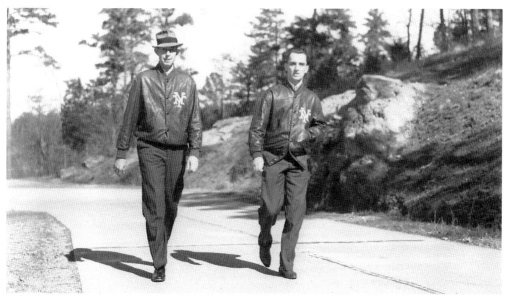

New York Giants pitchers Cliff Melton (left) and Johnnie "Hans" Wittig burn calories on Hot Springs Mountain Drive in the national park in late February or early March 1939. They had arrived on February 19, before the rest of the Giants batterymen. (Courtesy of the McKinzie Lambert Collection, Garland County Historical Society.)

BASEBALL IN HOT SPRINGS

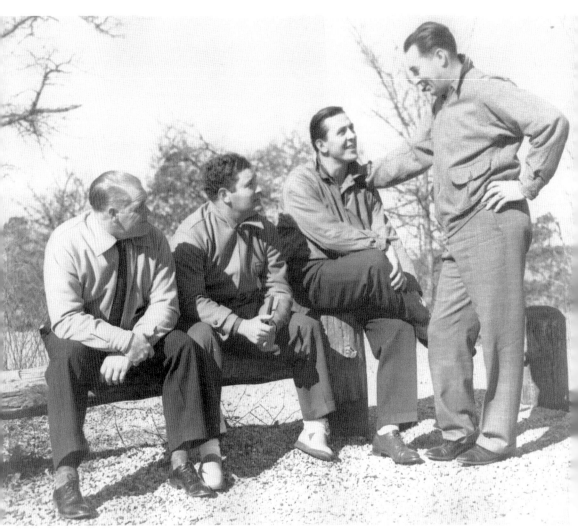

Pausing on a trail hike in February 1941 are, from left to right, Eddie Smith, Taft Wright, Julius "Moose" Solters, and coach George "Mule" Haas. The coach oversaw the group here for about three weeks. Solters was actually weighed on a sausage-factory scale before leaving the Windy City. The February 15 *Belvidere Daily Republican* reported: "Haas has the streamlining of the Chicago White Sox fat boys' brigade . . . progressing so speedily . . . that he's afraid the former beef trusters . . . will have to show their social security cards to prove their identity when they arrive at the regular spring camp in Pasadena. . . . Mule reported today that after two weeks of hiking and steam baths here the suet squad has shed a total of 43 pounds, whittling a bulging 640 pounds down to 597. . . After ten minutes of calisthenics at the ball park in the morning they set out on a two-hour hike over the mountains. At 2 p.m. they plunge into the thermal bath routine which takes two and a half hours in all. One and a half hours of this is spent in the 'hot room' where the temperature is 103 degrees. 'The boys have just two meals a day,' says the Mule. 'It's even getting me in shape.' " (Courtesy of the Garland County Historical Society.)

BATHING AND HIKING

4

GOLFING

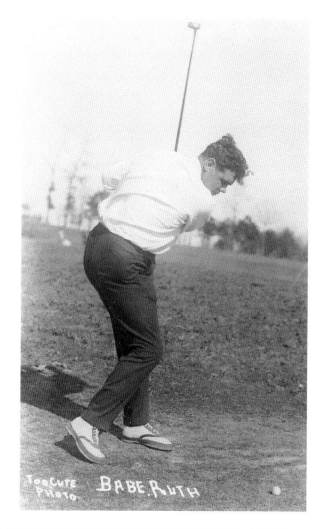

New York Yankees slugger Babe
Ruth employs a wood in the fairway
at Hot Springs Golf and Country
Club on February 24, 1922. By
the 1930s, this was known as the
No. 1 course, after the second
course was built. (Courtesy of the
National Baseball Hall of Fame.)

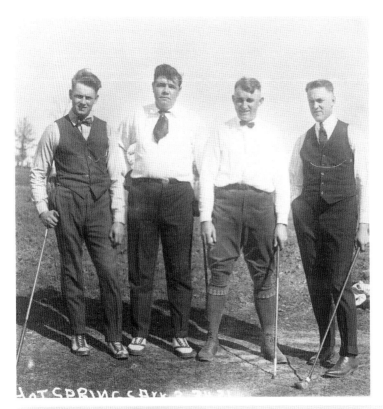

Posing on February 24, 1922, are, from left to right, Waite Hoyt (New York Yankees), Babe Ruth (Yankees), Carl Mays (Yankees), and possibly Al DeVormer (Yankees). The men are seen at Hot Springs Golf and Country Club. (Courtesy of the National Baseball Hall of Fame.)

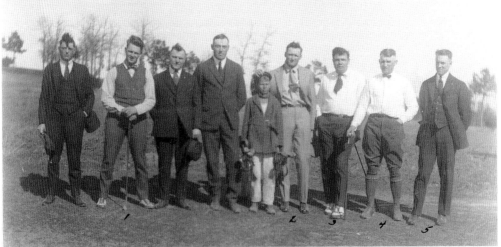

At Hot Springs Golf and Country Club on February 24, 1922, the baseball players indicated with numbers are Waite Hoyt (1), Walter Johnson (2), Babe Ruth (3), Carl Mays (4), and possibly Al DeVormer (5). Walter Johnson of the Washington Senators—in the Spa City with teammates Clyde Milan, Donie Bush, and Howie Shanks—was recovering from a significant loss: his two-year-old daughter, Elinor, had died of spinal meningitis a few days before Christmas 1921. The youngster beside Johnson is unidentified, but he may be future golf legend Paul Runyan, who caddied here during this period. (Courtesy of the National Baseball Hall of Fame.)

GOLFING

Waite Hoyt (back) and Everett "Deacon" Scott of the Yankees await their turn for the teasing shot over the lake hole on the Country Club course in late February or early March 1924. Before 1922 in Hot Springs, Scott had supposedly never played 18 holes. According to the March 1, 1923, *Evansville Courier and Press*, Scott "went lame in both legs after tramping over a water-logged course" here. Golf was many a baseball star's preferred exercise—but it was not without its hazards. Alta Smith took this photograph. (Courtesy of the Garland County Historical Society.)

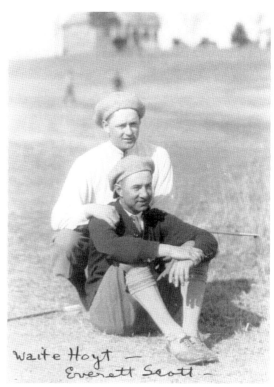

Waite Hoyt —
Everett Scott —

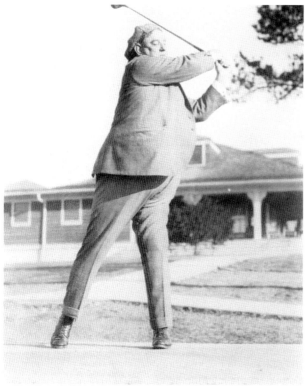

The New York Yankees' former half-owner, Col. Tillinghast L'Hommedieu "Cap" Huston, swings a driver in Hot Springs around 1923. He served in the Spanish-American War and World War I. He also orchestrated the famous March 5, 1922, coin flip with Babe Ruth to settle the Bambino's annual salary ($50,000 or $52,000). Ruth won the coin toss, which took place in Huston's room at the Eastman Hotel. (Courtesy of the Garland County Historical Society.)

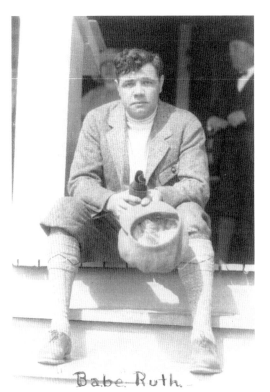

Babe Ruth rests in his golfing togs at Hot Springs Golf and Country Club around 1924. His face appears to betray the story of a disappointing round. (Courtesy of the Garland County Historical Society.)

Babe Ruth.

Spiffily attired, Cleveland player/manager Tris Speaker addresses the ball at Hot Springs Golf and Country Club in the early-to-middle 1920s. Some managers felt that golf distracted their players during spring training, but Speaker disagreed. (Courtesy of the Garland County Historical Society.)

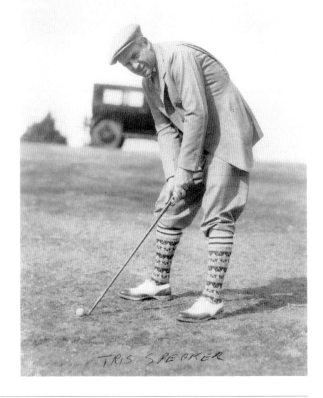

TRIS SPEAKER

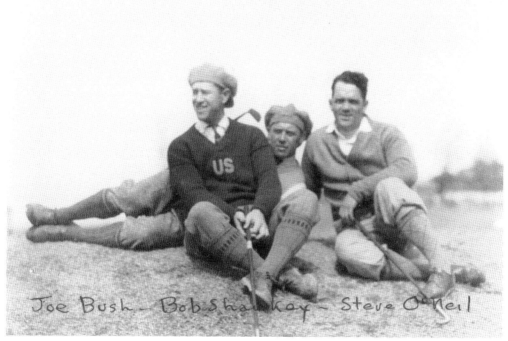

Joe Bush — Bob Shawkey — Steve O'Neil

From left to right, pitchers Leslie "Bullet Joe" Bush and Bob Shawkey, and catcher Steve O'Neill relax at Hot Springs Golf and Country Club in 1924 or 1925. Bush was a member of the Herb Hunter All-Stars team that toured Japan in 1923–1924, indicated by the "US" on his V-neck. (Courtesy of the Garland County Historical Society.)

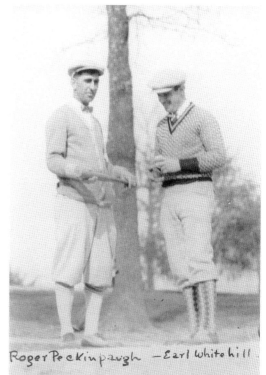

Roger Peckinpaugh — Earl Whitehill

In their plus fours at Hot Springs Golf and Country Club in the middle or late 1920s, Roger Peckinpaugh (left) of the Washington Senators and Earl Whitehill of the Detroit Tigers hold a bat and ball, symbolic of the American pastime. Both were fond of the Scottish game, too. (Courtesy of the Garland County Historical Society.)

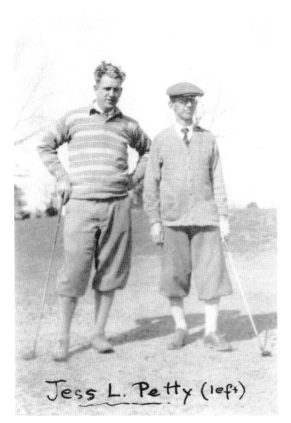

Jess L. Petty (left)

Jess Petty (left) of the Brooklyn Dodgers is shown at Hot Springs Golf and Country Club in February 1928. The February 12 *Brooklyn Eagle* identified the man at right as William Brune, "a Robin rooter of 1112 Albemarle rd." in the borough's Prospect Park South neighborhood. (Courtesy of the Garland County Historical Society.)

Philadelphia Athletics hurler George Earnshaw follows through on his practice swing at the Hot Springs Golf and Country Club in January 1931. On February 6, 1932, he eagled the 408-yard 14th hole of the No. 3 course, according to the *Reading Times*. After driving down the fairway "about 300 yards . . . taking a No. 7 iron, Earnshaw lifted his approach shot perfectly, on a line for green and the cup. While the foursome watched with bated breath, the ball rolled steadily to the cup and trickled in, for a deuce." (Courtesy of the Garland County Historical Society.)

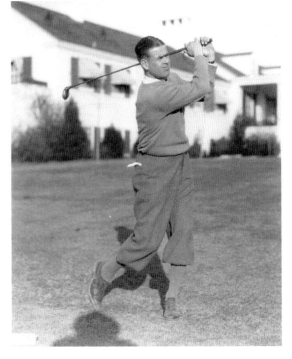

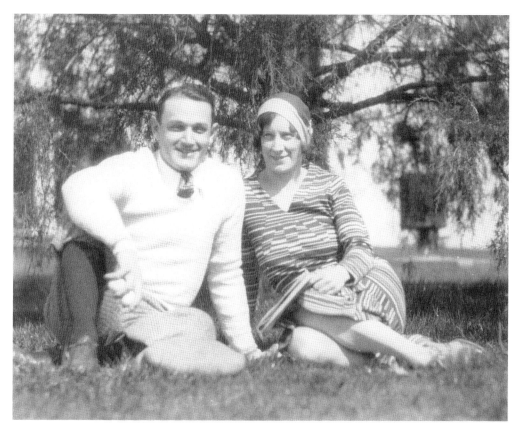

Harry Rice of the Washington Senators and his wife spend some time together in 1931, probably at the Hot Springs Golf and Country Club. Note the golf balls in his right hand. (Courtesy of the Garland County Historical Society.)

Willis Hudlin of the Cleveland Indians takes it easy at Hot Springs Golf and Country Club, shirt off in the heat, in the early or mid-1930s. Born in 1906, in what would soon be called Oklahoma (it achieved statehood in 1907), he resided for much of his life in Arkansas. Hudlin managed the Little Rock Travelers between 1941 and 1946, and died at Little Rock in 2002. (Courtesy of the Garland County Historical Society.)

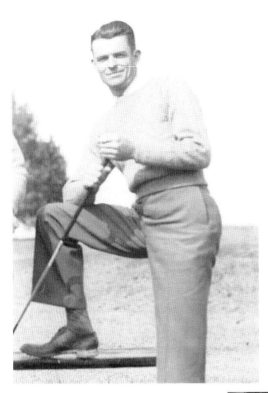

Tommy Bridges of the Detroit Tigers, seen here at Hot Springs Golf and Country Club in 1935 or 1936, was here for two weeks in January 1936 with manager Mickey Cochrane, Al Simmons, and fellow Motor City pitcher Lynwood "Schoolboy" Rowe. They bathed, hunted, and golfed, and Bridges signed his 1936 contract. He then returned home to Nashville, Tennessee, and was in Lakeland, Florida, by the end of the month. (Courtesy of the Garland County Historical Society.)

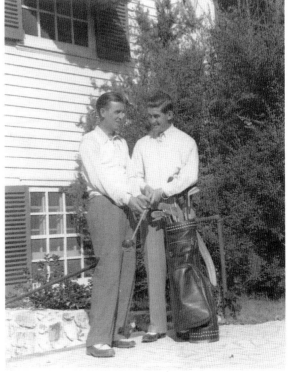

Ralph "Cy" Perkins (left) and Mickey Cochrane renew their friendship at Hot Springs Golf and Country Club in the mid-1930s. Both were catchers, and Perkins mentored Cochrane when they played for the Philadelphia Athletics. Now, Cochrane managed the Tigers, and Perkins coached for him. (Courtesy of the Garland County Historical Society.).

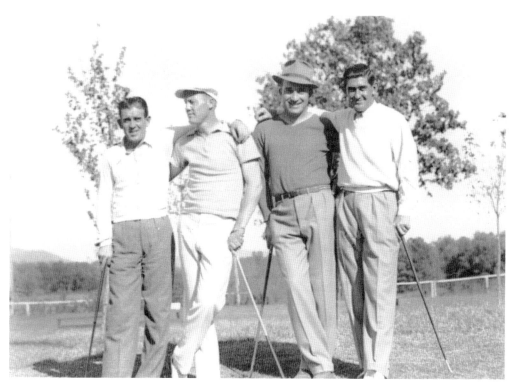

Posing here are, from left to right, Cy Perkins, Willis Hudlin, Al Simmons, and Mickey Cochrane. They are at Hot Springs Golf and Country Club in the mid-1930s for a round of golf. Hudlin and Simmons often hosted other ballplayers visiting the Spa City. (Courtesy of the Garland County Historical Society.)

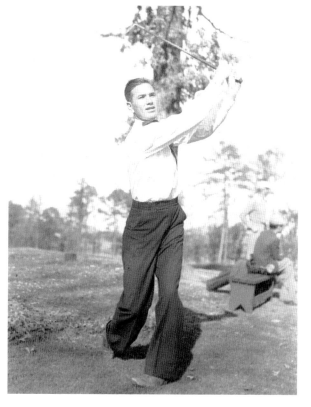

Dizzy Dean concentrates on his irons game at Hot Springs Golf and Country Club in early 1935. According to the *Alton Evening Telegraph* of February 13, "Dizzy has gone in for golf here in a big way. His lowest score is 76, but 'I am getting better every day,' he said." (Courtesy of the Garland County Historical Society.)

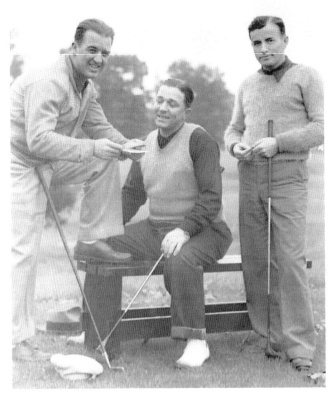

Kentucky governor-elect and future major-league baseball commissioner A.B. "Happy" Chandler (left) vacations at Hot Springs Golf and Country Club in November 1935. Sitting on the bench is Joe Burman of Hazard, Kentucky, a key aide to Chandler during the gubernatorial campaign. At right is outgoing congressman John Young Brown Sr., whose son was also destined to be governor of the Bluegrass State. According to the November 13 *Lexington Herald*, Chandler shot 42-39–81 for "a tour of the difficult No. 1 course . . . where par is 72." Chandler would return to Hot Springs in March 1937. (Courtesy of the Garland County Historical Society.)

Al Simmons (left), an unidentified man, and Willis Hudlin (right) rest on a bench in the mid-1930s at Hot Springs Golf and Country Club. The two ballplayers came, respectively, from Milwaukee and from a small town in the Sooner State, but each found Hot Springs and its golf courses to his liking. (Courtesy of the Garland County Historical Society.).

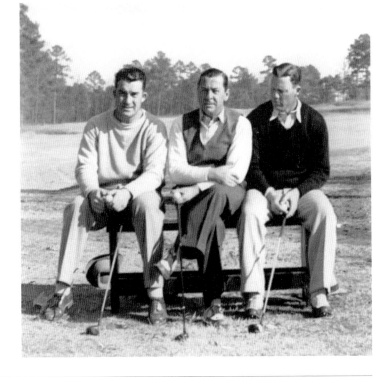

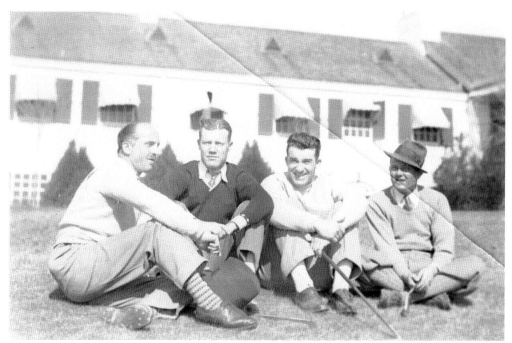

Shown above in the 1930s are, from left to right, E.W. James (a lumber executive from North Carolina), Cleveland pitcher Willis Hudlin, hard-hitting Al Simmons, and possibly Gilbert "Gib" Sellers, at the Hot Springs Golf and Country Club. Sellers won state open championships in Arkansas, Oklahoma, and Michigan and competed in senior golf tournaments as late as 1963. Below, on February 27, 1936, at Hot Springs Golf and Country Club, six golfers pause for a photograph. From left to right are Byron L. "Bones" Niemeyer, Washington pitcher Earl Whitehill, unidentified, Dr. H. King Wade Sr. of Hot Springs, Cleveland pitcher Willis Hudlin, and Nick Overstreet of Hot Springs. Niemeyer and Overstreet were part of the foursome that witnessed George Earnshaw's 1932 eagle (see page 94). Niemeyer was the manager of the Fordyce Baths from 1933 to 1962. (Both, courtesy of the Garland County Historical Society.)

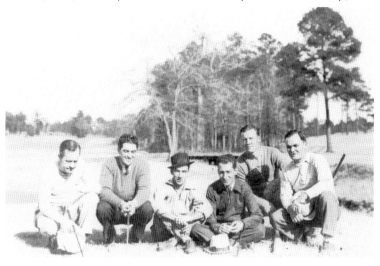

Posing here are, clockwise from top left, Al Simmons, possibly Jimmy Norton, Dr. H. King Wade Sr. of Hot Springs, and Nick Overstreet of Hot Springs. Norton was the Scottish-born club pro here from 1922 to 1937. Wade's son and grandson were also physicians, and Simmons had given the former an engraved wristwatch after the youngster had accurately predicted a Simmons blast in St. Louis. The inscription read: "From Al Simmons to H. King Wade, Jr., twenty-first home run, 7-13-30." This image was taken at Hot Springs Golf and Country Club in the 1930s. (Courtesy of the Garland County Historical Society.)

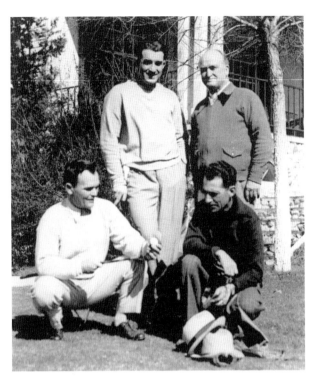

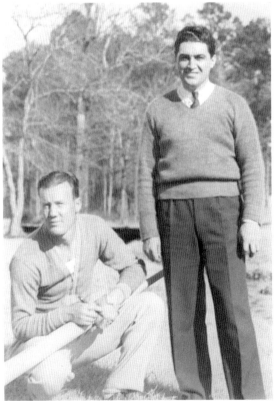

Willis Hudlin (left) and Earl Whitehill step away for a separate photograph on February 27, 1936. The accompanying press release explained that Cleveland manager Steve O'Neill granted Hudlin "an extra ten days at Hot Springs, Ark., for the federal baths." The *Macon Telegraph* reported that the Senators southpaw "stopped his golf game with Willis Hudlin" to shed light on his contract situation: " 'I'm not a holdout—but a holder-on,' Whitehill laughed. 'I've lost 10 pounds of surplus avoirdupois and am in fine shape. I'm leaving Sunday for camp [at Orlando, Florida] where I'm sure the differences between me and the club will be ironed out.' " (Courtesy of the Garland County Historical Society.)

5

LOCAL TEAMS AND PLAYERS

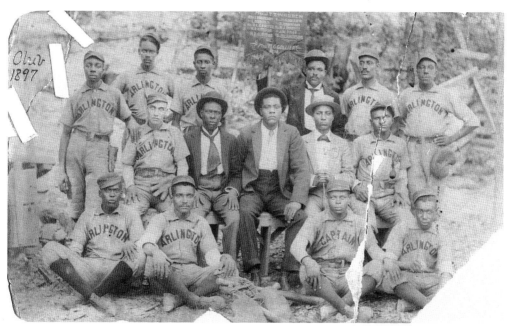

The Hot Springs Arlingtons were named after a preeminent Hot Springs hotel, and at least some of the players worked there. The team competed against other African American clubs for nearly a decade, traveling to diamonds as far away as Pensacola. The location of this c. 1896 photograph is not known. (Courtesy of Special Collections, University of Arkansas Libraries, Fayetteville.)

This 1905 team from Jones School includes Earl Smith, believed to be the catcher who later played in the majors. "Oil" Smith was born in 1897 in Sheridan, Arkansas, but his family moved here soon afterward. After retiring, he lived in Hot Springs again. Smith died at Little Rock in 1963. Another youngster in the image is Hill Wheatley, who became a Hot Springs real-estate mogul. His name still adorns a number of buildings downtown. (Courtesy of the Garland County Historical Society.)

A Hot Springs amateur team poses at Whittington Park in 1916. Note the upturned collars, fashionable in that era. The players are, from left to right (first row) L. Longinotti, McQuintes or McQuirter ?, Elbert Fulton, and Rawson; (second row) unidentified, Leo McLaughlin, Verne Ledgerwood, Whisenant ?, Hinkle, and Shorty Strock. Orval Allbritton wrote that McLaughlin, the city's mayor between 1927 and 1947, "and [McLaughlin's] old high school classmate, Municipal Judge Vernal S. Ledgerwood, would organize one of the strongest political machines in the history of the South." (Courtesy of the Garland County Historical Society.)

Arthur S. Riggs, player/manager for the Hot Springs Vaporites, leans on a railing in 1908. His team that year finished 78-38 and won the Arkansas State League pennant. A pitcher on that club, Jim "Hippo" Vaughn, went 9-1 that year and later won 178 games in 13 major-league seasons. Riggs was born in May 1887, played for bush-level teams from 1904 to 1910, and managed in the minors as late as 1922. (Courtesy of M. Beau Durbin.)

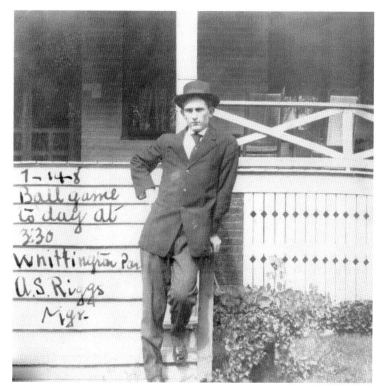

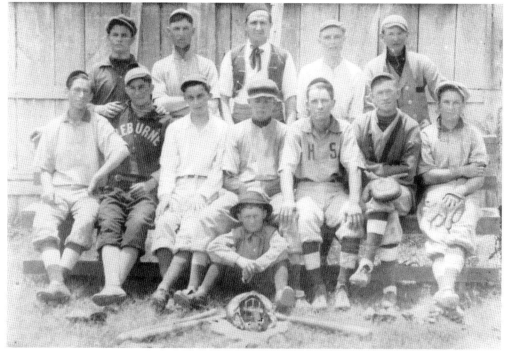

A team of mostly teenagers is captured on film sometime between 1914 and 1916. The location appears to be Whittington Park. (Courtesy of the Garland County Historical Society.)

Hundreds of baseball fans exit Whittington Park late in the afternoon of April 5, 1921. They had just witnessed a three o'clock game between historically black Arkansas Baptist College, of Little Rock, and an African American team from Hot Springs, the Vapor City Tigers. This was the second game of the series; how the tussle came out is anyone's guess, but the Bengals walloped the Buffaloes 11-4 the previous day at McKee. On April 7 at the same location, Rube Foster's Chicago American Giants beat the Tigers by a score of 6-1. (Courtesy of the McKinzie Lambert Collection, Garland County Historical Society.)

This photograph of a player and another man was taken around 1920. It was discovered in the attic of an empty house several decades later. The men's identities remain a mystery, but several African American teams existed here during that era. Jazz musician Junie Cobb of Hot Springs (later of Chicago) organized one such club in 1915. (Courtesy of the Garland County Historical Society.)

LOCAL TEAMS AND PLAYERS

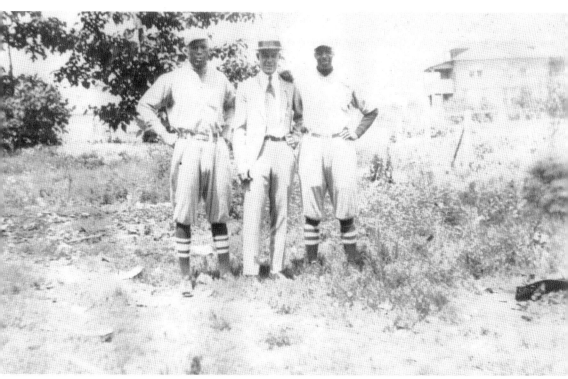

Taken at the same time and place as the previous image, this c. 1920 photograph suggests that the African American team to which the players belonged may have had a white manager. That was usually not the case, and the team was not necessarily local. Numerous clubs passed through Hot Springs on barnstorming tours. (Courtesy of the Garland County Historical Society.)

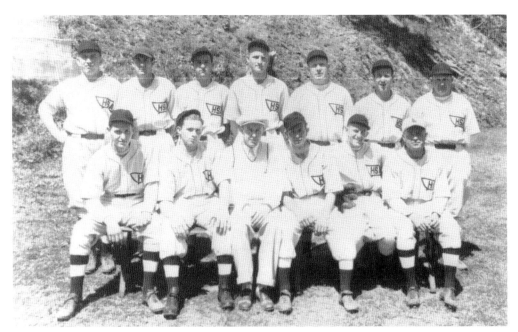

Pictured above, this semipro team was preserved on film at Whittington Park around 1931. The jersey logo consists of the letters "HSA" (Hot Springs, Arkansas) in a bathtub, advertising the most famous industry in Spa City. The player seated third from right appears to be Tommy Bosson. Another young team, shown below, again with a motley assortment of uniforms, is pictured at what may be Fogel Field around 1925. From left to right are (first row) unidentified, Jess Brown, Theodore Johnson, Waldo Pool, Tommy Bosson, and John Joe Shaw; (second row) Bruce Harris, Floyd Halsell, Dick Nance, Raymond Thompson, Paul Phillips, and manager Charles R. Woody. This team may have represented Hot Springs High School, where Woody taught gym classes and coached. (Both, courtesy of the Garland County Historical Society.)

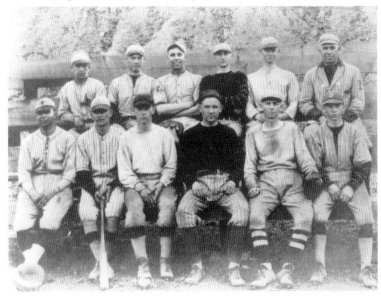

LOCAL TEAMS AND PLAYERS

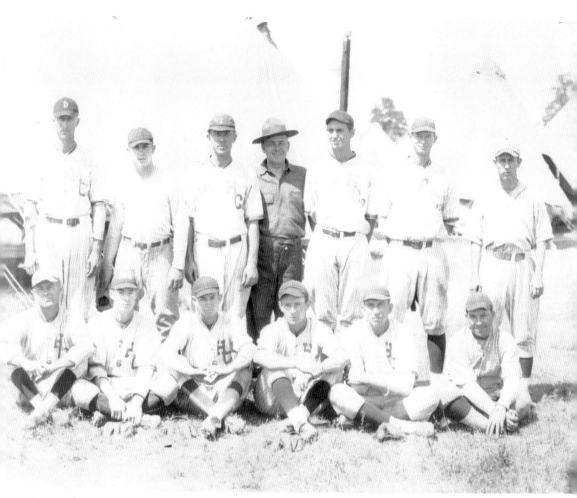

The 216th Hospital Company, Arkansas National Guard, was organized in Hot Springs on September 15, 1922, and demobilized on June 26, 1931. Sportswriter Roy Bosson recalled: "This team [c. 1930], most of whom were 'ringers' and never drilled a day with the National Guard, won the Guard Annual Encampment tournament at Camp Pike (now Robinson) almost every year." Some played in the minors. Pictured are, from left to right, (first row) Roy "Gilly" Gillenwater, "Cornshucks" Thomas, Tommy Bosson, Theodore "Dumb" Johnson, Jack "Paddlefoot" McJunkin, and John "Bull" Carrigan; (second row) Ralph Haizlip, Bruce Harris, Lefty Avant, George Pakis ("Manager and head of the unit's Mess Dept."), Slim Edwards, Paul "Country" Phillips, and "Rip" Kirkham. (Courtesy of the Garland County Historical Society.)

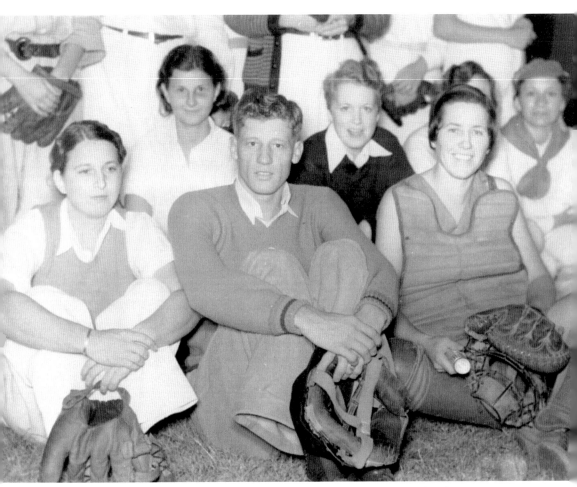

On October 19, 1933, Cubs pitcher Lon Warneke called the balls and strikes during a Hot Springs charity game between two all-women parent-teacher nines under the lights. Proceeds benefited the PTA milk fund. On November 1, 1932, Lon Warneke had done the same. On that previous occasion, baseball commissioner Kenesaw Mountain Landis threw out the first pitch, as the all-women teams battled for five innings. Blake Harper, a baseball executive with Cardinal connections and an off-season resident here, umpired the bases. In the 1932 game, Jones School defeated Rix School 13-11, the proceeds going to buy clothes for needy school children. Warneke, the "Arkansas Hummingbird," umpired in the majors from 1949 to 1955. (Courtesy of the McKinzie Lambert Collection, Garland County Historical Society.)

On his 41st birthday, June 26, 1947, Hot Springs Bathers manager Joe Kuhel gets a traveling bag— something any pro baseball player or manager could appreciate—and a kiss from Miss Hot Springs contestant Dorothy Gullet at Jaycee Park. In 1948, he piloted the Washington Senators, for whom he played first base a few years earlier. (Courtesy of the Garland County Historical Society.)

Joe Kuhel gets a traditional cake for his birthday, and a smooch from the night's master of ceremonies, Bill Bailey. Afterward, the Greenwood Dodgers won the game. (Courtesy of the Garland County Historical Society.)

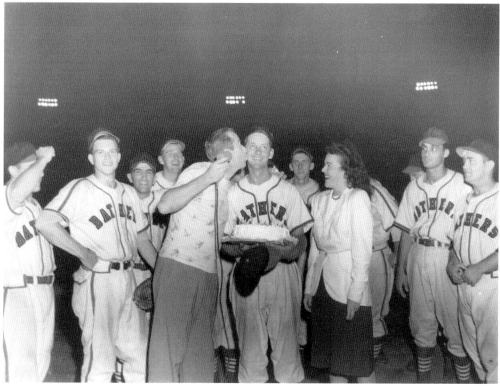

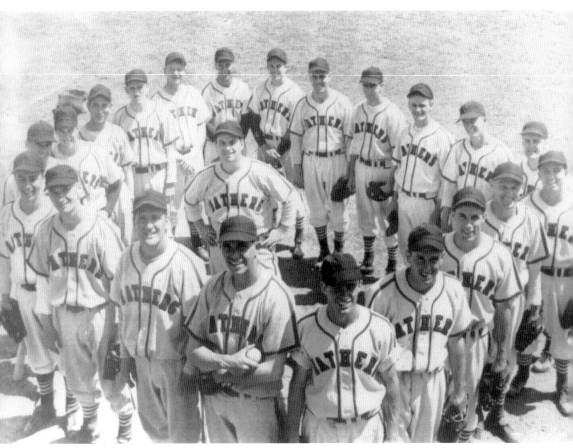

The 1948 Hot Springs Bathers finished third in the Cotton States League regular-season standings, with a record of 82-56. The team, which led the CSL in attendance, qualified for the playoffs along with the Greenwood Dodgers, Clarksdale Planters, and Natchez Indians. The Bathers won the league championship by first sweeping the Planters three games to none, and then defeating the Dodgers four games to three. This photograph probably dates from the first half of the season. (Courtesy of the Garland County Historical Society.)

LOCAL TEAMS AND PLAYERS

The Hot Springs Bathers' Herb "Sparky" Adams was named the CSL most valuable player in 1948; the outfielder won individual league crowns in batting average, runs, hits, and total bases. He played for the Chicago White Sox in 1948, 1949, and 1950. His final year in the minors was 1959, with the Mobile Bears of the Southern Association. This photograph is dated September 4, 1948. (Courtesy of the Garland County Historical Society.)

Dick Strahs went 19-7 in 1948, his only season with the Bathers, and threw a perfect game at Jaycee Park (site of this photograph) against the Pine Bluff Cardinals. He pitched in nine games for the 1954 Chicago White Sox, all in relief, without garnering a decision. In his minor-league career, though, he racked up over 100 wins. (Courtesy of the Garland County Historical Society.)

BASEBALL IN HOT SPRINGS

Genora Zini, better known as Tony Zini, was born in North Little Rock. He caught for the Hot Springs Bathers in 1947 and 1948, hitting at a .266 clip the latter year. He also made the 1948 all-star roster. After the 1950 season, Zini left the minors for Fayetteville, where he got a degree at the university and began a long career with Exxon. The photograph date is September 4, 1948. (Courtesy of the Garland County Historical Society.)

Hot Springs was the initial stop in Ed McGee's professional baseball career, and 1948 was his only season with the Bathers. The right fielder from Perry, Arkansas, batted .273 and paced the club in extra-base knocks with 46. Between 1950 and 1955, he patrolled center, at times, for the Chicago White Sox and Philadelphia Athletics. (Courtesy of the Garland County Historical Society.)

LOCAL TEAMS AND PLAYERS

The 1948 Bathers' third sacker, Dick Fuller, is pictured on September 4. In his only year at Hot Springs, Fuller hit .245. He played for eight teams over six seasons. (Courtesy of the Garland County Historical Society.)

Charlie Schmidt played shortstop for the 1948 Bathers. He hit .302 and smashed 27 doubles for Hot Springs. His lifetime batting average was .300 over seven minor-league seasons, with a total of six clubs. Just why he is wearing what may be a Senators cap, while playing in the White Sox organization, remains a matter for speculation. He was born in Galveston. (Courtesy of the Garland County Historical Society.)

Art Hamilton, shown here on September 4, 1948, pitched for the Bathers in 1947. That year, he went 11-17 and chewed through 220 innings (tops on the club), but the next year he improved to 18-9 in 10 fewer games. The Austin, Texas, native won three playoff games against Greenwood in 1948, including the series clincher. (Courtesy of the Garland County Historical Society.)

Jaycee Park, under snow, awaits the coming of spring in the late 1940s or early 1950s. Located at the end of Winona Street, the park still exists, but it is solely the province of amateur teams now. (Courtesy of the Garland County Historical Society.)

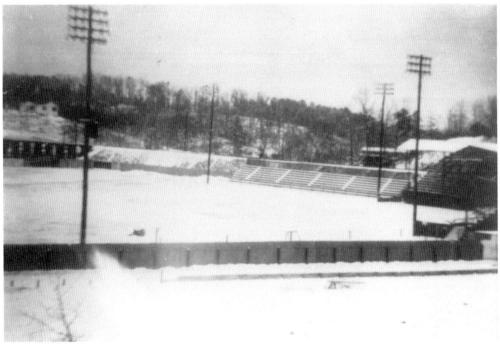

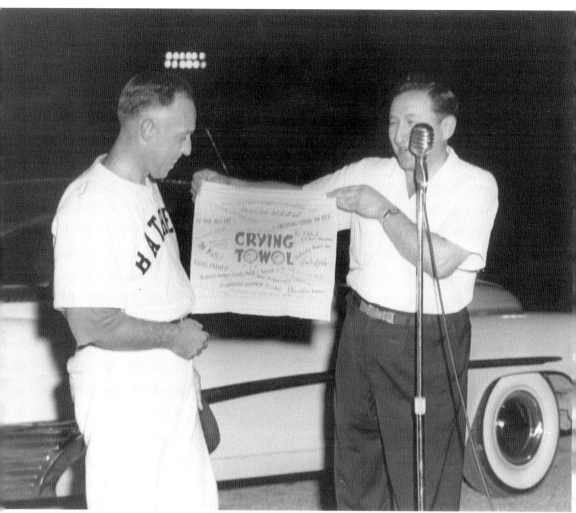

Hot Springs jeweler and team co-owner Lewis Goltz gives a "crying towel" to Bathers player/manager Vernon "Moose" Shetler at Jaycee Park in 1953. As a manager, Shetler had reasons to weep. The club signed a pair of talented African American pitchers, Jim and Leander Tugerson, that spring, but the segregated Cotton States League refused to change its rules and let them play. (Courtesy of the Garland County Historical Society.)

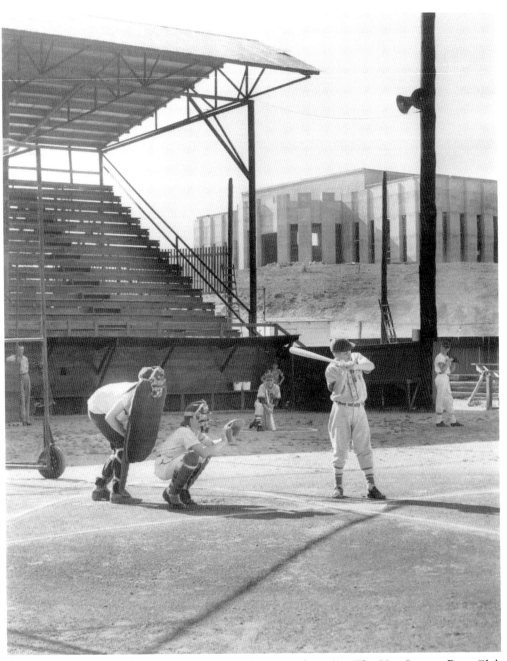

A newer generation makes use of Jaycee Park in the early 1950s. The Hot Springs Boys Club stands in the background; that building is still there today, part of the First Step School complex. Jackie Beavers bats for the Showmen's Club in this Boys Club baseball program game. In the on-deck circle is, probably, Sam Beavers. Phil Arman (far right) played college basketball and later coached at Lakeside High School. (Courtesy of the Garland County Historical Society, donated by the *Arkansas Gazette*.)

LOCAL TEAMS AND PLAYERS

BASEBALL SCHOOLS

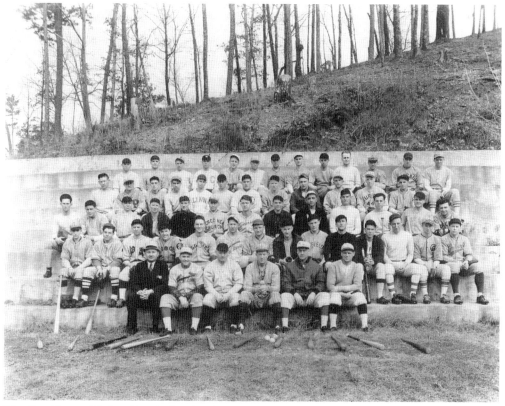

The Ray Doan All-Star Baseball School idea began when Doan, an amateur ballplayer turned slick promoter, was passing through Hot Springs with his House of David team. Men with big-league experience taught baseball fundamentals to youngsters from across the United States, for six weeks, and baseball scouts attended the classes, too, signing roughly a third of the players each year. Many of the students did obtain a berth on minor-league teams, but only a few reached the majors. Doan's initial class is seen here at Whittington Park in February 1933. Shown in the first row are, from left to right, instructors Doan, Rogers Hornsby, Leslie Mann, Grover Cleveland Alexander, Jack Ryan (also a scout), and George Sisler. (Courtesy of the McKinzie Lambert Collection, Garland County Historical Society.)

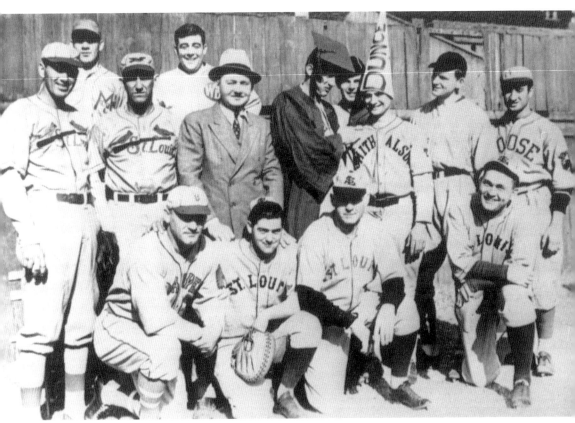

Faculty and several students of the Doan school are pictured in February 1934, possibly at Majestic Park. The Hot Springs Chamber of Commerce had leased the ballpark in January for Doan. Seen here kneeling are, from left to right, instructors Leslie Mann, Rollie Hemsley, Jack Ryan, and Rogers Hornsby. Standing behind them are, from left to right, Dizzy Dean, Mike Gonzales, Ray Doan, and Lon Warneke. Later in the session, Burleigh Grimes, George Sisler, and Johnny Mostil would join the staff, as some of the players and coaches seen here departed for training camps. (Courtesy of the National Baseball Hall of Fame.)

BASEBALL SCHOOLS

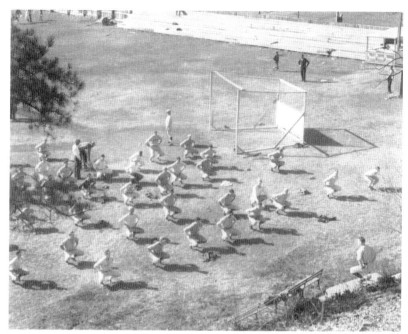

Above, instructors and students of Ray Doan's baseball school loosen up at Whittington Park in 1934 or 1935. These knee bends or squats were part of "setting-up exercises, a regular morning event," as described by the *Sporting News*. In March 1934, Olympic medalist Mildred "Babe" Didrikson showed up at the school to check on her younger brother Arthur ("Bubba"), a student there. While in Hot Springs, she received pitching instruction from Burleigh Grimes. The two players on their haunches at center of the Majestic Park photograph below appear to be Babe Didrikson (left) and Miles "Spike" Hunter. Hunter's own little brother, Homer, was an enrollee at the school that year, too. Babe and Spike would be teammates on one of Doan's House of David squads that summer. (Above, courtesy of the Garland County Historical Society, donated by the *Arkansas Gazette*; below, courtesy of the Garland County Historical Society.)

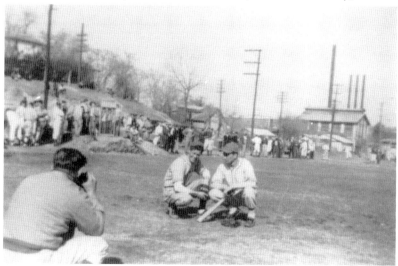

A 1936 chamber of commerce press release accompanied this photograph: "Hot Springs High School band out to welcome Professor Dizzy Dean on Dean Field . . . where the Cardinal ace is instructing students in the Doan Baseball School." Before 1935, Dean Field was known as Majestic Park, but now it honored the two Arkansas brothers pitching for St. Louis. (Courtesy of the Garland County Historical Society.)

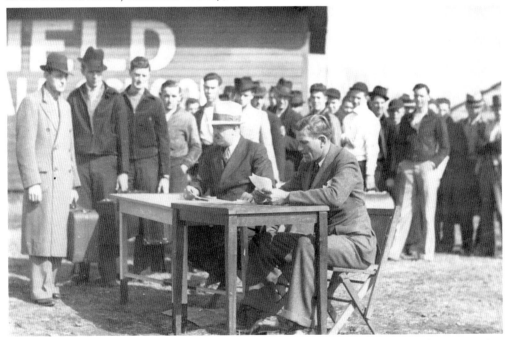

Ray Doan (seated, left) and Dizzy Dean register students for the new term in February 1936 at Dean Field. A total of 325 novice players signed up. A dozen or so won scholarships from the *Sporting News*, but most simply scraped together the $60 tuition for the six-week course ($50 if paid before January 20), plus about $7 per week for room and board. (Courtesy of the Garland County Historical Society.)

BASEBALL SCHOOLS

Lynwood "Schoolboy" Rowe, a Tigers pitcher who grew up in El Dorado, Arkansas, demonstrates his grip for students at the 1936 Doan school. A chamber of commerce press release accompanying this photograph read, "Left to right are Malcolm Little of Pembroke, Maine, who aspires to follow in Schoolboy's footsteps, Rowe, and Gerald Freeman of Waterville, Washington, who traveled the greatest distance to enter the school." (Courtesy of the Garland County Historical Society.)

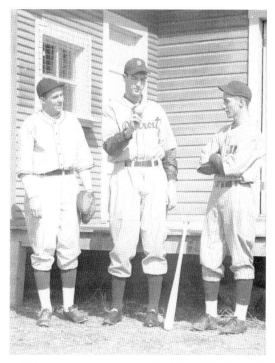

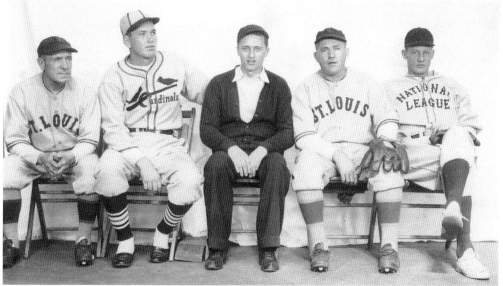

Each Doan School enrollee got a souvenir photograph of himself with his instructors. Seen here on February 16, 1937, are, from left to right, Charley O'Leary (Browns coach), Dizzy Dean, student catcher Vince Richardson, Rogers Hornsby (Browns player/manager), and Lon Warneke. "The Arkansas Hummingbird," recently traded to the Cardinals, is seen here wearing his uniform from the 1933 All-Star Game. A few weeks after this photograph was taken, Hornsby spirited another catcher and 1937 Doan school graduate, Ben Huffman, up to St. Louis to play for the Browns. (Courtesy of the National Park Service, Hot Springs National Park.)

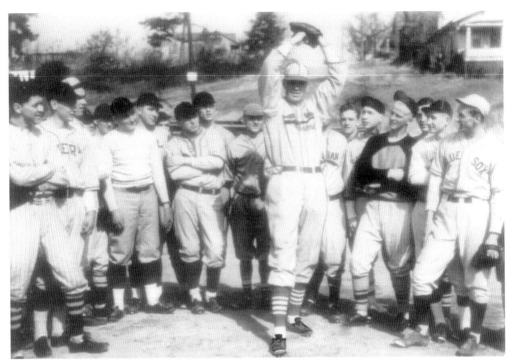

Dizzy Dean displays his windup for the tyro twirlers at Dean Field. A February 17, 1937, newspaper caption for the photograph read, "The subject of yesterday's lecture was: 'The Correct Way to Breeze the Ball Past the Batters,' or 'How I Became the Star I Am.'" (Courtesy of the McKinzie Lambert Collection, Garland County Historical Society.)

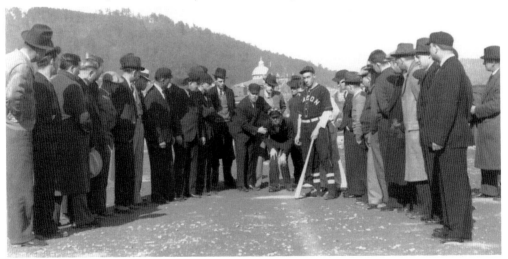

National League umpire George Barr ran a school for student umpires in Hot Springs from 1935 to 1940. At a location between Oak Street and Broadway, just behind the old Hot Springs High School, Barr teaches a proper ball-and-strike-calling stance around 1937. The batter is probably one of the Doan students. Barr's neophyte arbiters practiced by umpiring Doan and Hornsby school games. (Author's collection.)

BASEBALL SCHOOLS

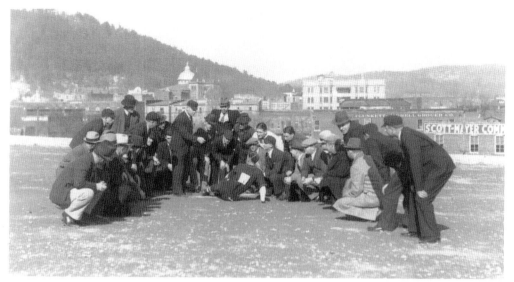

George Barr offers pointers on how to make a safe or out call at home plate, behind Hot Springs High School, around 1937. More than half his pupils found employment as minor-league umpires, and two even reached the majors. Minor-league presidents sent representatives to Hot Springs to scout these students, in the same way that minor-league teams had their scouts here to recruit the cream of the Doan school crop. (Author's collection.)

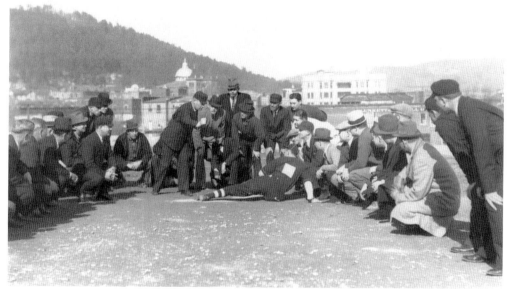

With a forceful "Out!" sign, George Barr is apparently emphasizing an umpire's need to exhibit certainty (even if he is uncertain) about a call. The *State-Times* of Baton Rouge overheard this tip from Barr at the school: "But if it's close, boy, that's where you've got to put it on. Give them a vigorous wave of the arm and a louder 'ye're out,' so that you've not only convinced the fans [but] the player as well." (Author's collection.)

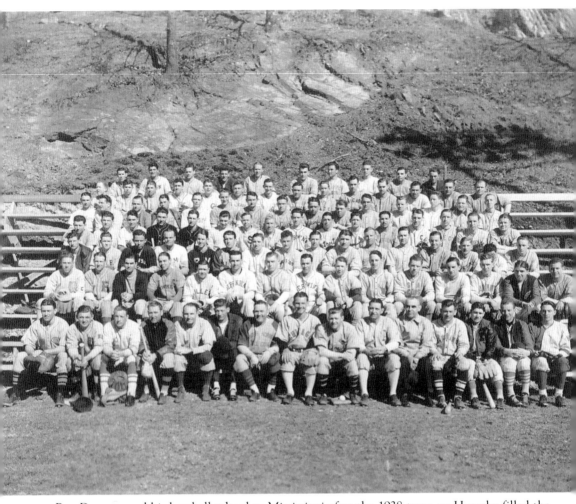

Ray Doan moved his baseball school to Mississippi after the 1938 term, so Hornsby filled the scholastic vacuum here with his Rogers Hornsby Baseball College starting in 1939. His last session here was in 1956. This photograph, taken at Ban Johnson Field (Whittington Park), is a class picture from the Rajah's 1939 academy. Included in the first row are, beginning fifth from left, instructors Dave Keefe, Lon Warneke (in umpiring gear), Hornsby, Gerald "Gee" Walker, Alphonse Thomas, Charley Berry, and Benny Meyer. Warneke's umpiring avocation would eventually blossom into a second career. (Courtesy of the McKinzie Lambert Collection, Garland County Historical Society.)

BASEBALL SCHOOLS

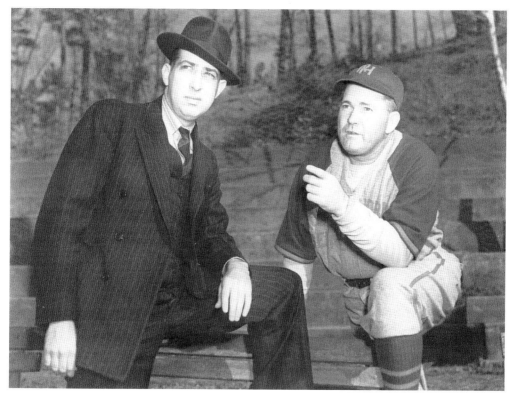

Rogers Hornsby (right) confers at Ban Johnson Field with Raymond "Hap" Dumont, president of the National Semi-Pro Baseball Congress, in March 1939. The burgeoning "Sandlot Movement" involved nearly a half-million players that year. The National Baseball Congress World Series is still played at Lawrence-Dumont Stadium in Wichita, Kansas. (Courtesy of the McKinzie Lambert Collection, Garland County Historical Society.)

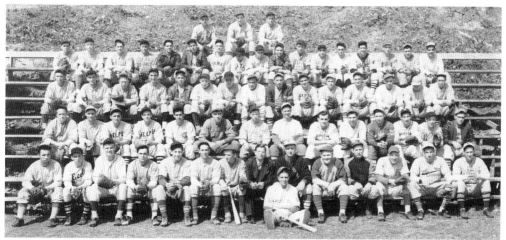

A Rogers Hornsby Baseball College class is pictured at Ban Johnson Field around 1940. Hornsby is in the first row, fifth from right, and Cardinals pitcher Lon Warneke is in the first row, second from right. (Courtesy of the McKinzie Lambert Collection, Garland County Historical Society.)

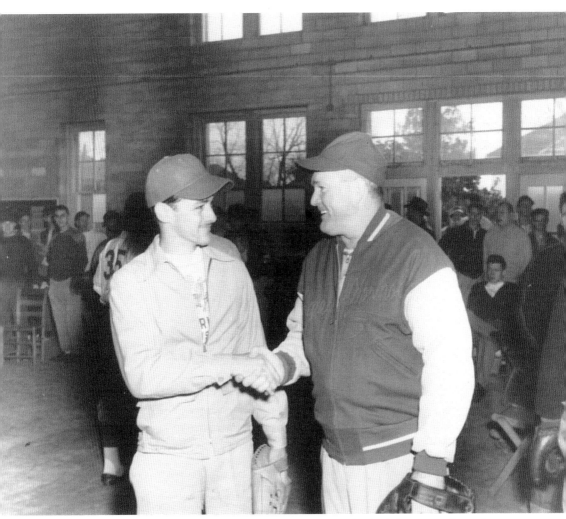

At a March 9, 1948, meeting of his students, Rogers Hornsby (right) congratulates the youngster who came farthest to attend his baseball school. Pitching prospect Ausberto Montaner y Bigay was from Ponce, Puerto Rico; his father was the accomplished hurler Francisco "Paquito" Montaner García, now enshrined in the Puerto Rican Sports Hall of Fame. Joe B. Scott of the Negro Leagues' Memphis Red Sox was also a Hornsby enrollee that year. The 1948 teaching staff included Birdie Tebbits, Don Black, Johnny Orr, John Mostil, Benny Meyer, Frank Parenti, Benny Huffman, and Orval Grove. Perhaps coincidentally, the Rajah managed the Leones de Ponce team in the winter of 1950–1951. (Courtesy of the McKinzie Lambert Collection, Garland County Historical Society.)

BASEBALL SCHOOLS

Hall of Famer Rogers Hornsby and his son Bill converse at Dean Field. Bill Hornsby was a minor-league outfielder between 1946 and 1951. He played briefly for the Hot Springs Bathers in 1948, the year of this photograph. (Courtesy of the McKinzie Lambert Collection, Garland County Historical Society.)

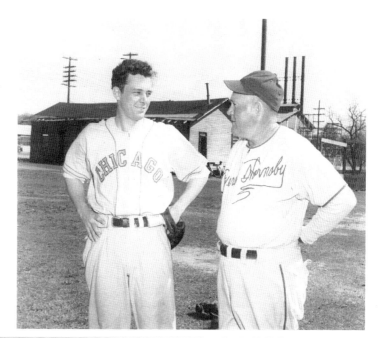

Rogers Hornsby visits with the staff at his Hot Springs baseball school in March 1955. From left to right are Mickey O'Neil (assistant to Hornsby), Archie "Abe" Miller (scout from Shreveport), Roderick B. Rice (Boston Red Sox scout), Bert Wells (Brooklyn Dodgers scout), Hornsby, L.J. Kelly (Milwaukee Braves scout), and Benny Meyer (chief aide to Hornsby). (Courtesy of the McKinzie Lambert Collection, Garland County Historical Society.)

Discover Thousands of Local History Books
Featuring Millions of Vintage Images

Arcadia Publishing, the leading local history publisher in the United States, is committed to making history accessible and meaningful through publishing books that celebrate and preserve the heritage of America's people and places.

Find more books like this at
www.arcadiapublishing.com

Search for your hometown history, your old stomping grounds, and even your favorite sports team.

Consistent with our mission to preserve history on a local level, this book was printed in South Carolina on American-made paper and manufactured entirely in the United States. Products carrying the accredited Forest Stewardship Council (FSC) label are printed on 100 percent FSC-certified paper.

MADE IN THE USA